₩₩₩₩₩₩₩₩₩₩₩ </2 W9-AKA-498

Ways with WATERCOLOR

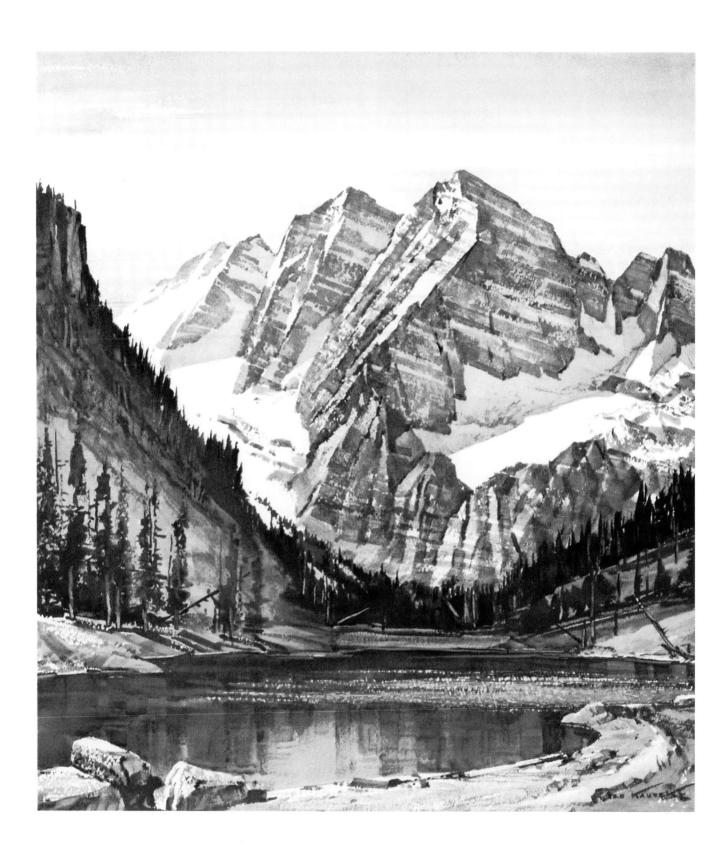

THE COLORADO ROCKIES

WAYS WITH WATERCOLOR

Ted Kautzky

DOVER PUBLICATIONS, INC. Mineola, New York

Bibliographical Note

This Dover edition, first published in 2004, is an unabridged republication of the second edition, enlarged, of *Ways with Watercolor*, as originally published by Reinhold Publishing Corporation, New York, in 1963.

Library of Congress Cataloging-in-Publication Data

Kautzky, Theodore, 1896–1953.
Ways with watercolor / Ted Kautzky.
p. cm.
Previously published: 2nd ed., enl. New York : Reinhold, 1963.
ISBN 0-486-43954-2 (pbk.)
1. Watercolor painting—Technique. I. Title.

ND2133.K3 2004

2004052659

Manufactured in the United States of America Dover Publications, Inc., 31 East 2nd Street, Mineola, N.Y. 11501

CONTENTS

Editor's Note
Introduction
The Color Pigments
Paper for Watercolors
Brushes and Other Equipment
Washes and Strokes
The Use of Accessories
Tips on Painting Buildings
Painting Skies and Clouds
Special Methods with Trees
Mountains, Hills, and Rocks
Reflections on Water
What Two Pigments Can Do
Now Let's Try Three Pigments
With Four Colors We Are Rich
The Winter Landscape
Village Vistas
Harbor Waterfronts
Along the Beach
More Practice

COLOR PLATES

The Colorado Rockies	Frontispiece
October in New England	11
New England Vista	14
The French Quarter in New Orleans	26
Sky, Rocks, and Sea	31
Winter in Vermont	34
View in The Great Smokies	39
Two-color Demonstration Paintings	47
Three-color Demonstration Paintings	50
Rocky Shore	55
Four-color Demonstration Paintings	58
Late Fall in Vermont	63
Along the Trail-Ridge Drive, Colorado	66
Winter Demonstration Paintings	71
A Country Church	74
Village Demonstration Paintings	79
Old Wharf	85
Harbor Demonstration Paintings	88
Beach Demonstration Paintings	94
Rocks and Reflections	99
Charleston, S. C.	103
Rural Pennsylvania	106
Shoreline at Cape Ann	107
Northeaster on Cape Ann	109
Schooner in Harbor	112
Stream in the North Woods	114
Yosemite National Park	115
Snow Peaks, Colorado	118
Colorado Foothills	119
New England in Winter	121
Toward Smuggler's Notch	124
Midwest Farm Scene	125
Along the Atlantic Coast	128
Morning on the Beach	129
Low Tide on the Beach	132
After the Storm	133
Along the Oregon Coast	136

EDITOR'S NOTE

The quality of any instructional book can be judged by its ability to keep winning new readers. A book that remains in demand, in spite of competition from many new books on the same subject, obviously has the meat that its readers want.

WAYS WITH WATERCOLOR is such a book. The first edition was printed in 1949 and it has been reprinted many times since then. But type and plates wear out eventually and then the publisher must decide whether to let the book go out of print or to make the considerable investment required for a new edition. This choice is always carefully weighed; and more often than not the final decision is against a new edition. About WAYS WITH WATERCOLOR there was no question. It had to be kept alive.

Why such esteem for this particular book? The answer lies in Mr. Kautzky's fidelity to a single purpose—to teach the beginning watercolorist how to handle his medium. There are no chapter deviations for subjects such as composition or perspective, yet his lessons are full of invaluable instruction in these and other related subjects. His simple, direct, teacher-to-student language and his purposeful illustrations go straight to his objective. Everything else becomes subtly interwoven extras.

And now, some years after Mr. Kautzky's death, we at Reinhold offer to the public this second edition of WAYS WITH WATERCOLOR. It has been enlarged, we believe, as he would have wished. His text, although updated where necessary, remains basically the same. New text has been added at the end. This edition contains 42 additional Kautzky illustrations — 19 black-and-whites and 23 color plates, including 10 paintings commissioned by the John Morrell & Company for one of their annual calendars and reprinted here for the first time.

Some of the additional illustrations are found within the basic text but most are in the back of the book, in a new section called "More Practice." Its purpose is implict in its title. In preparing this material, we have been mindful not only of Mr. Kautzky's injunction to practice, *practice*, PRAC-TICE but also of his personal teaching approach. An approach that invites you, in his own words: "to work with me; to watch, figuratively, over my shoulder."

ELEANOR GILMAN

INTRODUCTION

Painting creditably in watercolor is not beyond the reach of the average ambitious student or amateur, whether or not he attends an art school. If he has at least a little initial competence in drawing, the ability to see colors correctly, and willingness to work, he can learn enough to develop a pleasurable hobby into a possibly profitable profession. This book is designed to help such beginners by giving them enough elementary knowledge to get them started, plus the stimulation and encouragement they can get from seeing a number of good examples in full color.

I have not sought in the following pages to give an exhaustive treatment of the whole subject of watercolor, or to cover all that is known about the details of materials and technique. Rather, I have simply tried to describe and illustrate my own methods of working and to point out what I believe to be the important things to strive for in making watercolor pictures. Each artist has his or her own ways of visualizing and achieving results, based on individual temperament and experience. This is as it should be, for it would be sad indeed if we all painted alike. Yet there are certain fundamentals that all must share, and I have attempted to put them down so that the beginner can build upon a base of established knowledge as he proceeds to develop understanding and confidence.

The plan of the book is simple. The first chapters will acquaint the reader with the essential characteristics of the three kinds of material needed for making watercolors—the color pigments, the paper upon which they must be applied, and the equipment and tools to use in applying them. He will then be led through some elementary exercises in the laying of washes and the manipulation of the brush for special strokes. A few notes on the use of accessory implements will give him enough information so that he can quickly begin to practice on the elements of the landscape. The object is to get him at actual painting as soon as possible, for it is only by this process that he will learn. He will spoil plenty of paper, but it is in a good cause.

I have provided a graduated series of exercises in the making of complete landscape pictures; at first with a limited palette of two, three, or four pigments-then with as many as may be required by more elaborate subjects. With each example reproduced in full color, I have included the preliminary thumbnail sketch to show how I first established the arrangement and values. My own painting procedure is demonstrated by means of a black-andwhite reproduction of the picture half completed. As a further exercise in each case, I have given the student several pencil sketches from which to develop paintings at large size in watercolor. In one of these the values are indicated and he will have to make his own decisions as to the colors: another one is in outline, so that he must think out both value and color distribution. I do not wish to encourage copying so remember that these tasks are designed to help in developing independent thinking while the student is gaining proficiency.

There is an old saying among painters, that you have to make a hundred watercolors before you know how to make one properly. Essentially true but don't let it scare you. You will find, as I did, that though the work of learning is thought of as hard, it is really pleasurable; that each technical point you conquer brings its own separate satisfaction; and that the final mastery you win over the brush and color will give you the unequalled thrill of being able to paint without hesitation whatever your eye sees or your imagination can visualize. Is it a freedom worth working for? Well then, let's start to work—even though we start at the bottom!

THE COLOR PIGMENTS

If you are going to paint in watercolor, the first thing you will obviously need to know about is the color pigments themselves-the mineral, vegetable or, rarely, animal substances that are to be dissolved in water and applied to the paper surface with your brush. Some of them have a long history, going back to the prehistoric periods when man first smeared colored earths on the walls of caves; others have been developed by modern chemical science-but we're not going into either history or chemistry. What we want to know is how to identify the colors by sight and by name, in what form they are available, how each one behaves during application by itself and in combination with others, and how permanently they will retain their original hues under the action of light and polluted air.

Such facts, set down in printed form, can be useful as a guide to beginners and for occasional reference later on. But the only way to really fix them in your mind is through experience extended over time. Understanding this, I am going to give you here only enough information to get you started. Later on, when you are ready for more detailed knowledge, you can consult one of the specialized books available which deal exhaustively with painters' colors.

The business of providing artists' supplies has grown in modern times into a big industry. There are now art materials stores in most sizable communities throughout the United States, handling the products of a number of reliable manufacturers. Even in small towns there is often some variety or stationery store that sells at least the commoner colors, and if what you want is not in stock, the dealer can always order it for you by mail or you can write direct to one of the many firms which advertise in art magazines. So I know you can get the colors you need.

My advice is to always buy the best colors you can afford. It does not pay to use cheap ones. Those provided by the best manufacturers do not vary greatly in price. Personally, I prefer colors made by Winsor & Newton or Grumbacher—two worldfamous brands. But you may wish to choose some other reputable manufacturer, for each artist has his own favorite brand, which he has found by experience to give him best results. The watercolor paints I use are of the sort classed as "transparent." I do not use "opaque" watercolors at all. Transparent colors come in cakes, pans, and tubes; I prefer the tubes as giving quicker solubility, an important consideration when working rapidly while washes are wet. Before beginning to paint, I squeeze out a plentiful supply of each color I am going to use into the wells of my color box or palette, where it is immediately available for mixing. In the event that I should run short during a big wash, it would take only a moment to squeeze out more. With cake or pan colors, which are solid and dry rather than pasty and moist, it would take so much time to dissolve enough pigment that my wash would dry out while I did it.

The hues available to artists in prepared watercolors number well over a hundred, but no artist I ever knew uses more than a fraction of the total. Many of the unusual colors are fugitive (liable to fade) and are shunned for that reason if for no other. The principal manufacturers commonly recommend that the painter make his choice from a list of fifty or sixty fairly permanent colors and it is rare to find a painter today who habitually uses more than twenty. In any single painting, he is likely to confine himself to ten or less. I often work with but three or four colors, as you will see.

When you come right down to it, all this great array of available pigments can, for the practical purposes of a working palette, be reduced to half a dozen small groups; the primary reds, blues, and yellows constituting the most essential colors, and the less vivid greens, browns, and grays the rest. With the primaries it is theoretically possible to mix the entire range of the spectrum, but for convenience, to save time and trouble, greens and browns are handy to have. The grays, including black and white, can be omitted entirely, since you paint on white paper and other shades of gray can be produced by mixing complements or triads. The oranges may be considered as reds or yellows, depending on which way they lean. For violets or purples there is ordinarily little use; when you do need them it is easy to mix red and blue.

For my own working palette, which is shown in orderly arrangement on page 13, I have two reds, four yellows (one is an orange), three blues, four browns, a green, and two grays (one warm and one cool). This does not mean that I never use any others; simply that I find these sufficient for most purposes.

Of the reds I have selected, the Alizarin Crimson is a deep rich red. The Vermilion is a lighter and more vivid color, approaching orange; in fact, I often use Orange Vermilion in its place. Some colormen and artists counsel against using the Alizarin, which is a coaltar derivative, because it is said to be affected chemically when mixed with some of the other colors such as the cobalts, the chromiumoxide greens, and the common "earth colors" ochres, siennas, and umbers. I have not found any serious difficulty of this sort in my watercolors, perhaps because I do not use a great quantity of this red. If you have any fear of it, you can substitute one of the Cadmium Reds, but you will find it hard to match the hue of the Alizarin.

In the yellow segment, I have chosen a set of four, which graduate in their paleness from the *Cadmium Orange*, which is slightly tinged with red, through the *Cadmium Yellow* and the *Aureolin* (or *Cobalt Yellow*) to the delicate *Cadmium Lemon*, commonly called Lemon Yellow. They are all reliably permanent and fairly transparent.

For the blues, I use *French Ultramarine* most often. It is a rich, intense blue which mixes well, gives a good range of values, and has a certain degree of opacity when used heavily. It has another interesting property—that of lending itself to the production of "settling washes," either alone or combined with some other pigment like *Burnt Sienna* or *Burnt Umber*, usually on rough or medium-rough paper. The *Cobalt* is somewhat lighter, also settles, and is useful in painting summer skies, etc. *Winsor Blue* is a cold, heavy, clear blue, and I often use it or the similar *Antwerp Blue* for painting cool skies and mountain scenery. Other colors are of course mixed with any of these blues to produce a large variety of related hues as needed.

Among the oldest pigments known are the socalled "earth colors," which are made from heavy mineral oxides found in the natural soil. Most painters throughout history have used them and they have a high degree of permanence. Of these, I like to use a good deal of the two siennas and the two umbers, all of which I class as browns, though the *Raw Sienna* might be regarded as a dull yellow. For landscape painting they are highly appropriate and useful. Most of their pigment particles lie on the surface of the paper, consequently they can be more easily washed out or "lifted" than colors that penetrate into the paper. In heavy washes the umbers and siennas are opaque.

I only use one green, Hooker's Number 2, mixing it with yellow or blue to lighten or darken it. It is a fairly bright green, much more so than the Viridian and Terre Verte favored by some because of their greater permanence. You could, if you wished, substitute the recently developed Phthalocyanine Green, sometimes called Thalo Green or Monastral Green, which is similar to Hooker's Number 2. Other greens can be produced, as you probably know, by mixing blue and yellow.

This brings us down to the grays, of which I use two. Davy's Gray is the warm one; Payne's Gray the cool. They lend themselves to mixing into sky washes, foggy effects, etc. Occasionally, I employ Sepia—one of the very few animal colors, made from the protective secretion of a cuttlefish—for special purposes. It is a very warm gray, almost brown, and is excellent for monochrome painting or value studies. With it you can make any value from pale gray to black.

Most of the colors I use in my palette create their effect by the deposit on the paper of a sediment made up of small particles of solid matter of varying degrees of fineness, depending on the grinding that was done by the makers. A few, however, are dye colors, which penetrate into the pores of the paper. The Alizarin Crimson and the Winsor and Antwerp Blues are of the latter type. In general, the sediment colors are easier to remove from the paper after they have dried on it, either by erasing or by rewetting and lifting off with brush, sponge, or cotton rag. The dye colors are hard to lighten or remove. There are certain places where these peculiarities may be taken advantage of to produce interesting effects. For example, if I apply a mixture containing say Burnt Umber and Winsor Blue in painting a tree trunk or a rock, I can use strokes of a knife blade, held tilted against the wet paper in a way that I will demonstrate later, to remove part of the heavier brown pigment and leave lighter areas where the contrasting dye color will show through. With these knife strokes I can model the surface and indicate reflected light.

Most public schools teach the rudiments of color mixing, so you probably already know that in pig-

OCTOBER IN NEW ENGLAND

Size of original: 22" by 30". Painted on 300-pound Whatman, rough surface. *Order of painting:* 1. Chimney, roof, and shady side of center house; dark shadows behind the two figures and on sunny side of house. 2. Shady side of house on right; one wash starting at cornice and brought down over façade, outside staircase, and shadow over grass and street. 3. Shadow at left and tree trunks and limbs in shade. 4. House and bushes at left, rear. 5. The two sunlit elms, with foliage. 6. The yellow house, half lighted, with the roofs and chimneys at the right. 7. The sky. 8. Sunny part of the center of interest. All painting done as directly as possible, with final colors and values.

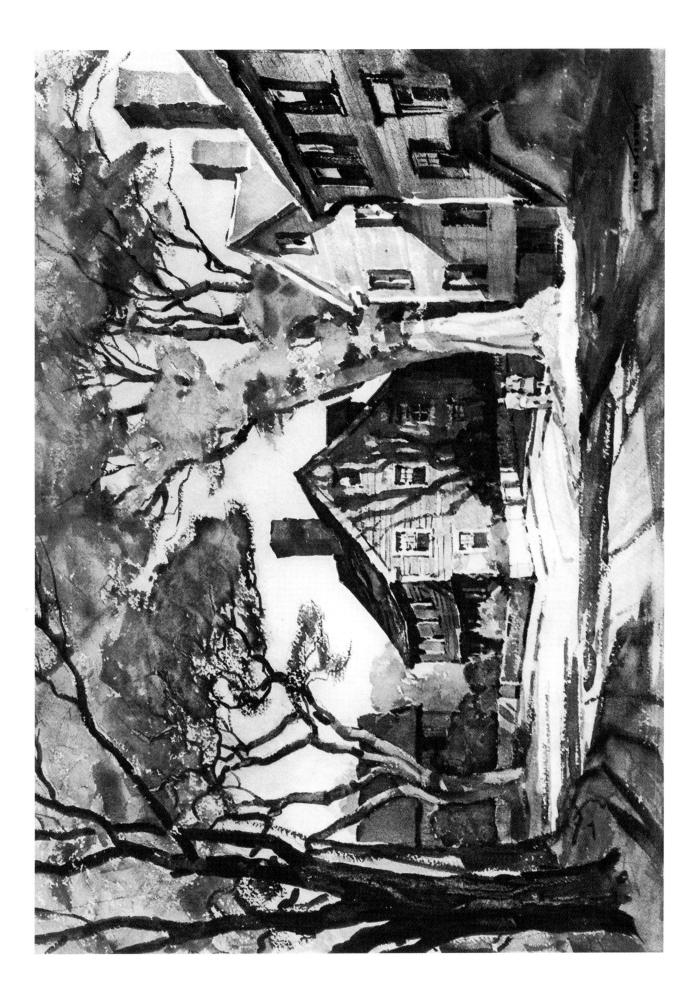

ment mixing, pairs of the primaries (red, yellow, and blue) give the secondaries (orange, green, and violet), and that each intermediary (yellow-green, blue-green, etc.) is made by mixing a primary and a secondary. You also probably know that if these hues are arranged in a circle in the order in which they appear in a spectrum, the pairs diametrically opposite each other are called complementaries.

However, to refresh your memory, you may wish to make a color wheel similar to the one shown below. Draw the circles on a piece of white drawing paper; from a piece of cardboard cut out the triangle and projecting pointer. Place the cutout on top of the drawing, in the position shown, and pierce both with a thumbtack, flattening the projecting pin against the underside. Now fill in the small circles with the colors indicated-the primary colors first. Then mix and fill in the secondaries (yellow and blue makes green, blue and red makes violet, red and yellow makes orange); and finally, mix and fill in the third, or intermediary colors (yellow and green makes yellow-green, green and blue makes blue-green, blue and violet makes blueviolet, and so on around the circle).

As the cutout is turned, the three corners of the triangle will always point either to the primaries, as shown below, to the secondaries, or to three of the six intermediaries. The two C's, which are diametrically opposite each other, will always point to complementary colors.

Pairs of complementaries have interesting interrelationships; in mixtures they neutralize each other, producing grays; in juxtaposition they intensify each other, sometimes dazzlingly. Painters take advantage of these and many other fascinating facts that you will have to learn as you proceed. I am not going deeply into the matter here; if you wish to delve into the optical and psychological effects of combinations you can refer to one of several good books that are available in most libraries. For present purposes, however, you will learn better by doing and observing, rather than by reading.

You cannot get too well acquainted with your pigments, and I advise you to spend some time thoughtfully trying them out under different conditions. Observe how each one behaves by itself, when applied in light, medium, or dark values. Note its degree of transparency and remember at what value it seems to be most intense in hue. Then try mixing pairs with a view to finding out the range of colors possible for each combination. Be as systematic about all this as your nature permits and make pencilled notes to help you remember the things you observe.

As you proceed to paint, you will of course learn more from each picture you do, but it is mighty handy to know beforehand just what colors to pick out of your palette to give you a certain effect in mixture. Study juxtapositions of color and see what one does to another when you place them side by side. Which pigments settle in washes, and which dye the paper most strongly? There are thousands of things to learn if you will take the trouble. Other painters have learned them; so can you!

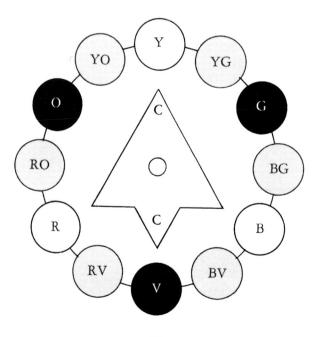

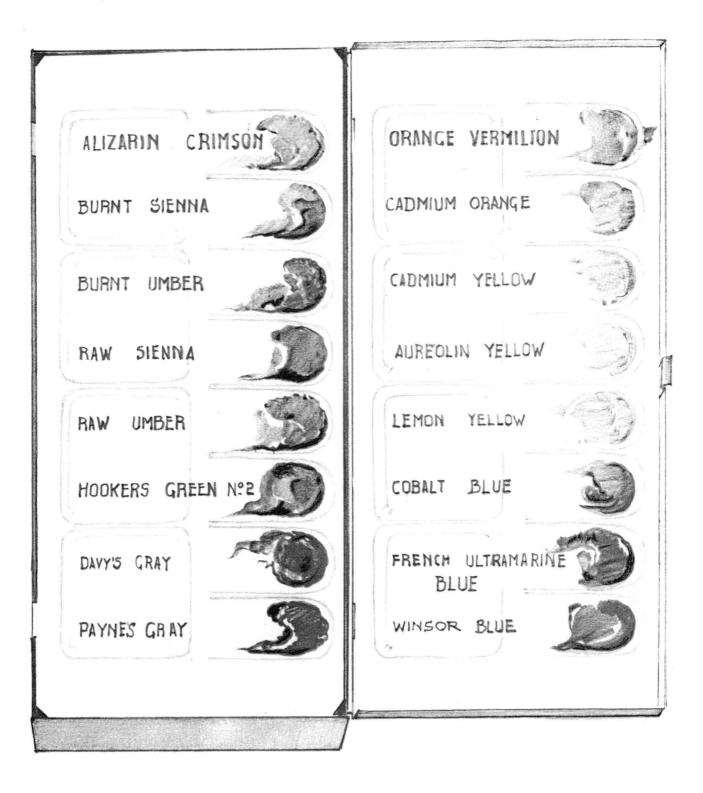

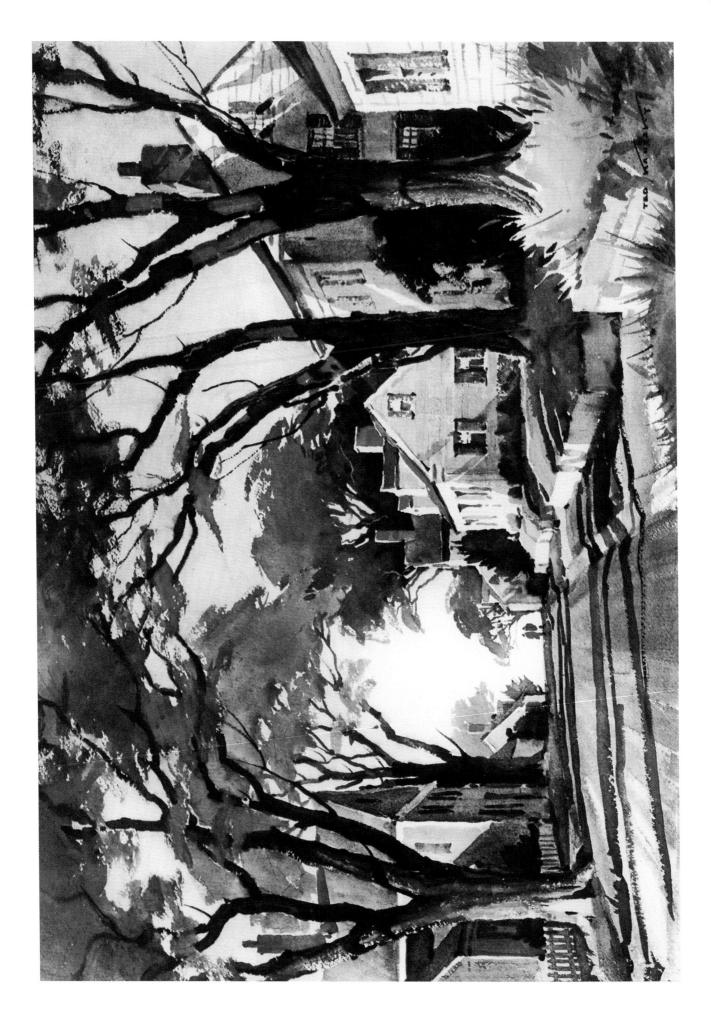

NEW ENGLAND VISTA

Size of original: 22" by 30". Painted on 300-pound rough Whatman. *Order of painting:* 1. Foreground tree trunks and foliage. 2. Shadowed parts of houses at left and right. 3. Road and shadows across it. 4. Grass, bushes, and background trees; foreground grass and detail of house at extreme right. 5. Sunny house forming center of interest. 6. Sky and small silhouetted figures. With the exception of some of the shadows, all washes were applied direct in their final colors and values. Before the colors you have bought can be transformed into paintings, they must be spread upon a surface. What kind of surface will be most suitable? Generations of painters have experimented with all sorts of materials, so their experience is at your disposal. They have collectively found that paper of certain controllable qualities furnishes the base best adapted to the peculiar needs of watercolor painting.

First, our paper should be of the best linen-rag stock, so that it will not deteriorate with age and will keep its color and strength permanently. For the present, at least, we will want it to be white, so that the transparent colors we place upon it will show up without distortion. Textures of several degrees of roughness or smoothness should be available, to lend themselves to a variety of desired effects. The roughest of these should still be smooth enough to draw on legibly and comfortably with a pencil; and the smoothest should have tooth enough to hold the particles of dissolved pigment so that they will not slide along with the wet brush as we make our strokes. Our paper should also be absorbent to just the right degree, so that it can draw water from the wash into its substance-but not too rapidly for convenient manipulation of the wet color. When wet, paper will stretch, for that is its nature. It must, therefore, be heavy enough to resist buckling when subjected to large washes. Finally, it must be strong and durable, both when wet and when dry, for it must stand a certain amount of abuse during painting, especially when corrections or erasures are to be made.

There are several brands of paper which fulfil these requirements. They are all handmade, and most of them are imported. Consequently, they are fairly expensive; but, as with the colors, it pays to get the best. Whatman and D'Arches are my favorite makers, for I have found that I get the best results with their products. But some painters prefer other brands, such as R.W.S. (made in England for the Royal Watercolor Society), Fabriano, or A.W.S. (American Watercolor Society). The D'Arches, because of its good absorptive quality, is particularly excellent for outdoor painting. You will probably try out different kinds as you continue to paint, and will decide for yourself what suits you. You may find that the papers vary in color, even within the same brand, so pick sheets as white as possible.

I prefer to work on a rough or medium-rough surface and to have the paper heavy enough to prevent buckling. The 300- or 400-pound weight is ideal for my way of working, though I sometimes use a lighter weight for smaller pictures. The sheets come 22" by 30" and can be halved or quartered, if you like, to give well proportioned sizes. Mounted Whatman's is available in several degrees of roughness. It consists of a thinner sheet backed up with stiff cardboard, which completely eliminates buckling. A drawback is that it has only one side to work on; you cannot turn it over and begin again in case you have made a bad start. Also, several together are heavy.

To give you a rough idea of the way the color acts on different surfaces, I have made some washes and strokes, reproduced opposite. Number 1 is a flat wash on rough paper; you can see its pleasant texture. Beside it, at 2, I have shown how various brush strokes look on this same paper. The glittering effects are known as "dry-brush strokes," although the brush was fairly wet when they were made. Later, you will learn how to make them, for they are very useful.

At 3 and 4, I have made a graded wash and some strokes on cold-pressed, mounted Whatman's, which is not so rough but still has a good texture. The gradation of the wash was accomplished smoothly, with no trouble from wrinkling or buckling. Contrast this with 5, where I worked on a lighter weight, smooth paper and found that buckling made it hard to get an even result. Papers of 140 pounds or less must be stretched in some way if you are going to do washes of any size on them. One method commonly used is to wet the paper thoroughly and mount it on a regular canvas stretcher, folding back and fastening the edges with thumbtacks as shown in 6. When it dries, it will be tight and should not buckle. Be careful not to strain the paper as you tack it in place, for if you get it too tight it may break when it contracts. There are other ways to stretch paper, but this one is practical.

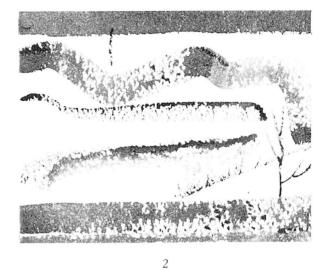

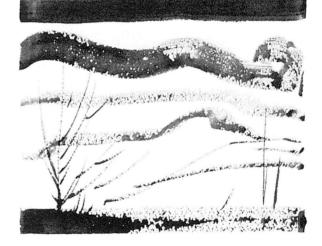

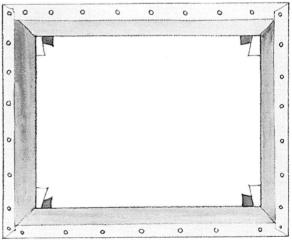

Finally, we come to the consideration of the tools and equipment needed for the process of making watercolor paintings. They do not make an elaborate list-no more than those pictured. Brushes of good quality are the most important. If properly treated, they will last for years. So do not buy cheap ones that soon go to pieces and do not work well even when new. You will need a couple of round ones of about the sizes shown (number 2 or 3, and 12). If you can afford it, these should be red sable. If not, get brushes made from a mixture of red sable and choice ox hair. Cheaper still, but without the snap of red sable, are camel hair and a variety of others. For the bulk of the work, I recommend flat, square-end, sign painter's ox-hair brushes half-inch size for general use and one-inch for large washes and broad strokes. The beginner tends to think that small brushes are necessary for details, but as he becomes familiar with brush handling, he will discover that these large flat brushes are capable of doing amazingly fine strokes when used edgewise, so that the smaller ones need not be often called upon except for the most delicate work.

You will need a good piece of soft natural sponge, of about the size shown, with which to wet large areas or to manipulate color on certain occasions; also a supply of cotton rags or toweling, cut or torn into pieces about a foot or foot-and-a-half square. These are convenient for wiping brushes and for lifting color in areas you want to lighten. A 2B drawing pencil is an obvious need, for making preliminary studies and sketching in the lines of your pictures as a guide for painting. The knife is not just to sharpen the pencil, it is also used to make special strokes I will tell you about later. A few used razor blades will come in handy, too, and some kneaded rubber or artgum.

Your water supply is pretty important; you couldn't do much painting without it. In the studio, I keep a large, wide-mouthed tobacco jar, frequently replenished, during painting periods, with clean water into which to dip my brushes. Outdoors, I carry an army canteen which holds a quart, and a cup into which I pour enough water for immediate needs. Whatever container you select, be sure it is large enough; clean brushes mean clearer and more controllable color, therefore, a better painting.

There are a variety of color boxes on the market, containing room for enough tubes of paint and provided with some sort of white enamel palette, with wells for the pigment and spaces for mixing. Get as large a one as you can find. My own box, pictured opposite, measures $4\frac{1}{2}$ " by 12", and contains sixteen wells and eight mixing pans. I supplement the mixing area by keeping on my studio table a large, white enameled pan or tray, 12" by 18", to give me plenty of space to spread out into when needed. It is shown at the bottom of page 13. Your box and pan need not be exactly like mine, but you should have enough room for a good supply of pigment and for mixing large washes. The mixing areas should be white, so that you can judge accurately the color of your mixture before you put it on the paper. It pays to clean the palette well after finishing for the day. The still moist color pigments can be left in the wells, where they will not dry out too much overnight. If left for longer periods, put a moist sponge in the box before closing it.

When you paint outdoors, you will want to have a folding stool of some kind to sit on. I work either with my paper on the ground or propped up a little with a pillow or anything that will enable me to tilt the paper easily when I want washes to run. I sit on the stool, straddling the paper, and work leaning forward with brush in hand and color box alongside. In this position it is easy to sit up once in a while and get better perspective to judge the progress of the work. Some painters carry two stools, one for the paper, so that they can work at a higher level.

The last little object pictured in the lower right hand corner of page 19 is a piece of blotting paper, which is convenient for quickly soaking up any drops of water that may spill.

These are all the things you actually need. Chances are that you will add to them now and again by buying some of the innumerable gadgets you will see in supply stores. Every artist does so. But you don't need to clutter up your workshop to start with. Put any extra money into getting really good quality brushes, colors, and paper. You will be rewarded by better work.

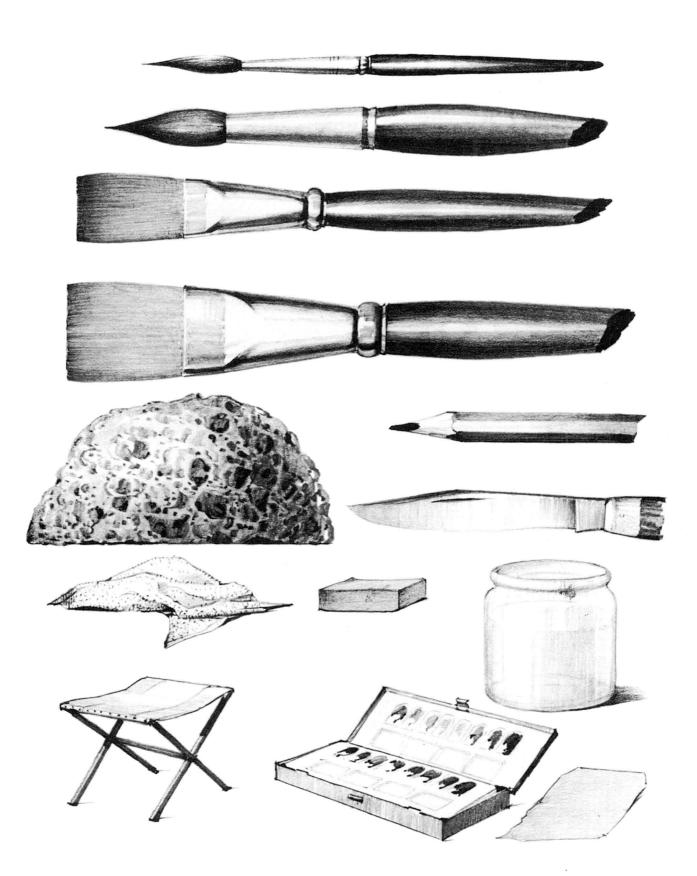

Making a watercolor involves two possible ways of applying color to the paper with the brush: laying washes and making separate strokes. Larger areas where the color extends continuously, with no white paper exposed, are the washes. Strokes are limited to the width of the brush, but within that width they may be solid or broken up with white. I have demonstrated opposite, and you are to practice, both flat and graded washes and both solid and broken (or dry-brush) strokes. Use a cheap, heavy, rough paper for the practice exercises, so that you will not be afraid to ruin many sheets. Clip the paper to a hard board and place it on your table. Then tilt the board toward you by placing a book under it.

For the flat wash, sketch a rectangle of convenient size, say 6" by 9". With your half-inch flat brush, mix some color in your mixing pan, using enough pigment to give a good dark value, similar to that of the illustration, and enough water to provide several full brush loads—more than enough to cover the area to be painted. Use your best judgment as to quantity; if you mix too much or too little, you can correct yourself on the next trial.

Now, with your brush loaded with as much of the wet color as it will hold without dripping, start in the upper-left corner of the rectangle and make a stroke along its top edge. Do not worry at this stage about following the line closely; the main point is to work lightly and rapidly, without pressure, wetting the paper all the way across. The surplus liquid will run toward the lower edge of the stroke, forming a long narrow puddle. The trick now is to move this puddle of wash down, gradually and evenly over the area, keeping it wet at all times but not so wet as to get out of control. This is done with successive strokes, each a little lower than the preceding one but overlapping it, and each made lightly with a full brush. When you get near the bottom you can use less liquid and finally take up the surplus liquid with a partly squeezed out brush. If you have worked properly, the area should dry out evenly into a smooth layer of color.

Next, try graded washes, working from light to

dark and then from dark to light. These are done by using proportionately more or less pigment in your mixture with each successive stroke. Beginning with clear water, you can add a little pigment each time you fill the brush between strokes, the quantity you add controlling the rate of gradation. In the reverse direction, you start with a dark value and add water each time you dip the brush, ending up with practically no color. Don't be afraid to keep practicing; the paper you spoil is not worth as much as the experience and skill you will gain.

While you practice washes, vary the monotony from time to time by trying some strokes. Learn how to control the flat brush. Make some solid strokes with its full width, watching to see how different amounts of color in the brush behave. If you hold the reasonably full brush upright, with its tip against the paper, and move it slowly, you should get solid color. If you move it swiftly, it will hit the high spots and some white will show through. Try holding the brush at an angle while moving it in curved strokes; notice how such strokes vary in width. Move it edgewise to make quite narrow lines of color. When you have some confidence, paint a little house with solid strokes, like the one shown. This was made with the half-inch brush.

So-called "dry-brush strokes" are made in several ways and with all sizes of brushes. I like to make them with the brush not really dry, but held lightly with its side against the paper so that the hairs glide longitudinally over the high spots and leave the little hollows between them untouched. The effect is glittering, suggesting sunshine striking textured surfaces. With the small brushes you can paint tree branches and twigs effectively this way. With the big brush you can start a stroke with the brush held upright, laying it over on its side as it moves to the right, and straightening it up again as you finish, as illustrated. This is a most useful stroke, and you will often want to use it for suggesting the bright shimmer of the sun on water, etc. Practice, Practice, and PRACTICE all these essentials of brush handling until you can produce any effect at will. It takes time to learn; no one does well at first!

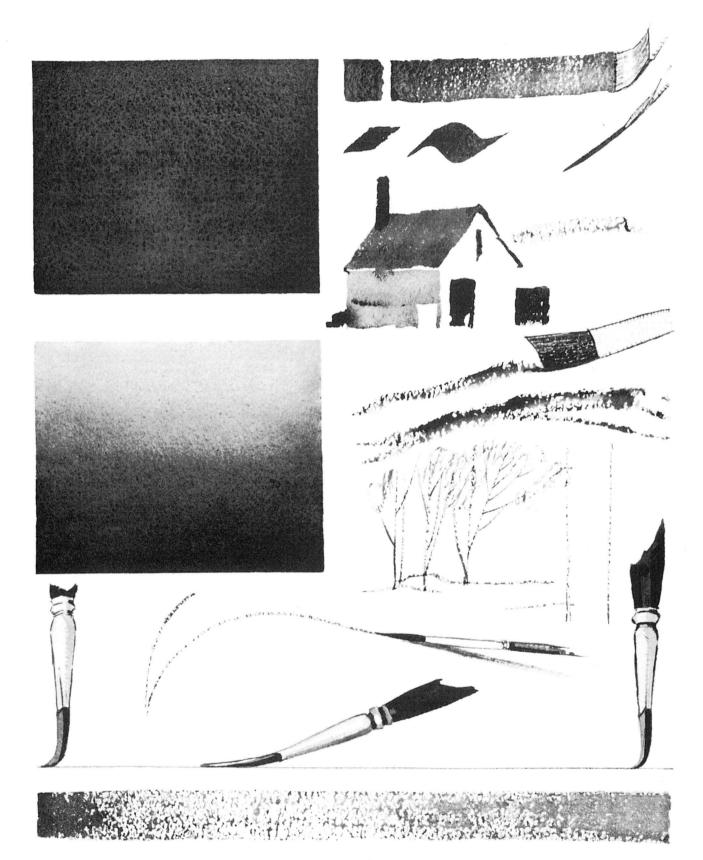

As you have learned, the brush can produce many special effects. A few simple accessory tools an ordinary pocket knife (not too sharp), a razor blade, cotton rags, a kneaded eraser, and masking material (tape or liquid)—will produce others. Practice with them in ways I will describe, so that you will be ready to use them where needed.

Illustration 1, opposite, shows an exercise in the use of the *knife*, with which the entire pattern of birch trunks and branches was made. The method is applicable under a wide range of conditions, but you should understand that the darker the wash and the smoother the paper, the more contrasting the knife strokes will be.

While the wash was still wet, but not too wet, I used the knife blade to squeeze out the paint, holding the blade tilted toward me at a slight angle with the paper, over which it should slide under pressure without scraping or scratching the surface. The curved edge of the blade permits you to vary the width of metal in contact with the paper, so that you can make strokes for all sizes of trunks and branches. The tip can be used for finer twigs. Experiment to become familiar with the way of holding the knife, the amount of pressure to apply, and the degree of wash wetness that will give proper results. (The process can also be used after a wash is completely dry by rewetting the area carefully with clean water in a lightly held brush.)

Not all of the pigment will be removed by the knife; some color will remain in the areas squeezed. In general, it is the earth color that comes off on the knife blade, while the more penetrating dye color remains. The objective is to produce controlled light strokes against dark, rather than to lay bare the original white paper. I use the knife frequently in my paintings and find it extremely useful. Practice gives control.

The *sponge* is another useful tool for special effects. I use it occasionally when painting skies. In this process, a good deal of water is involved, so the paper must be heavy to prevent buckling. With the working surface level, I wet the paper evenly with the sponge. While the surface is still shining with a thin film of water, I apply the pigments with

the large brush and model my sky. For corrections, as in Illustration 2, I use a damp sponge to pick up the pigments, completely to produce light clouds or partially to get a fleecy effect. This must be done while the sky is wet or you will get hard edges where you do not want them. A little glycerin in the water slows down drying, but too much prevents drying, so be careful.

The *razor blade* can be used effectively to scratch thin sparkling lines, unobtainable in any other way, to indicate ship rigging, clotheslines, etc., as in Illustrations 3 and 4. These lines are made after the picture is otherwise finished and dry.

Sometimes there are places where I want to depict light objects, such as the trunks of birch trees, seen against a dark background. For this, I use a cotton rag or the kneaded eraser to take out the light areas after the background has been painted. To illustrate this, I painted a winter scene with trees silhouetted against a dark sky and distant hills. Disregarding the trees, I painted the background all the way across. (Had I painted around the trunks, the continuity of the washes would have been broken; had I masked, the edges would have been too hard.) After the washes had dried, I took clean water in a small brush and wet the paper within the outlines of the birches, letting the water stand long enough to soften the pigment. Then I wiped it out with the cloth. If more color had to be removed, I could have used a kneaded eraser. The details of bark and twigs were added later, the light twigs being scratched in with the razor blade after the surface was dry.

In 6, I wanted clean, sharp edges for the boat masts, so I used strips of Scotch tape, cut to fit and stuck carefully in place. The sky and background could then be painted over them in a single wash. When dry, the strips were peeled off. Masking is often easier to do with a liquid frisket such as Maskoid. The technique is the same except that the liquid is brushed on and allowed to dry before putting a wash over it. Dry Maskoid peels or rubs off easily. I use masking devices only where hard edges are not objectionable.

Know these "tricks," but use them sparingly.

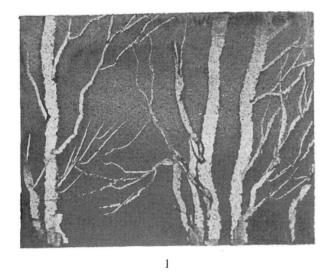

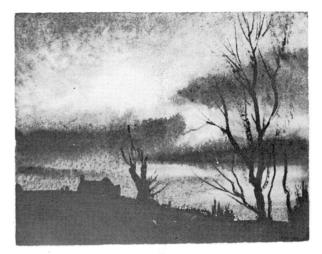

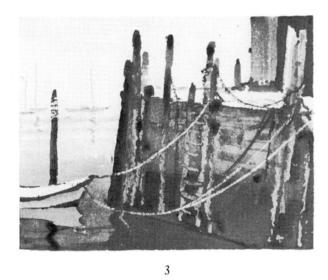

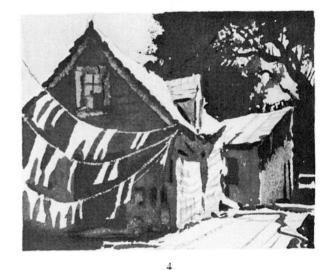

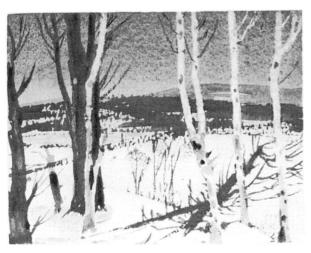

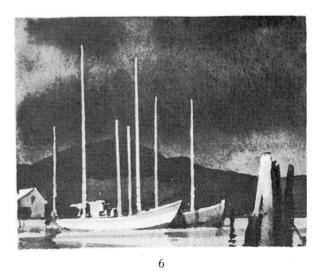

Buildings of various types, shapes, and sizes are often encountered in landscapes. Therefore it is well for you to know how to make them convincingly real and how to express the textures of their materials, at least the commonest ones. On the facing page, I have drawn a small stone house, a clapboarded house, and a shingled lobsterman's shack — all sunlit and seen from a close enough point of view to make the textures important to the success of the pictures.

In the stone building, I started with the dark values and worked toward the light ones, leaving the sunny side to the very last, thus ensuring that the center of interest would receive only enough detail to make it glitter. By putting in the background trees, roof, and shaded side of the chimney first, it was easier to gauge just how far to go in painting the lighter portions. Since the range of values was established first, there was little likelihood of going astray, an easy thing to do when working from light to dark. For the stonework, I put in first the darkest stones, very sparingly; then the middle-value stones, occasionally leaving the joints white. The stones were varied in size to give interest, as they are in actual masonry, and the very dark ones were made small for the sake of sparkle.

In Illustration 2, the subject and arrangement are similar, but the material is different. I have found that clapboards can be most effectively indicated when the sun strikes across the wall at an angle—they model better. Hence, I assumed the sunlight coming from the right and a little in back of my point of view. The order of painting was again from dark to light and, after putting the main shadows on the house, I had only to indicate the clapboard shadows with a small brush, being careful not to define every clapboard. The street side of the house, in full sunlight, needed only the barest suggestion for its door and windows.

In 3, the lobsterman's shack, I chose to have the sunlight striking the side of the building in order to give the shingles a sparkling texture. Again also I painted the darks first—the background tree, the darker details of the buildings, and the shadow under the wharf. These determined the values for our shingled wall, which is graded from the nearer corner to the more distant one, the darker end setting off the pattern of the lobster buoys hanging against it. To indicate the shingles, I used a flat, square-end brush, starting at the nearer corner with upright strokes, painting around the buoys, and finishing the wall with dry-brush strokes to give the shimmer of sun on the old wood. Then, with a fine brush, I indicated the somewhat irregular shadows under the shingle butts and picked out an occasional shingle with vertical strokes. A very few drybrush strokes on the roof made it glitter and the knife was used to get reflected light under the eave and on the background shack.

Illustration 4, with the center of interest in bright sunshine, was painted from dark to light background trees, building to right, foreground shadow, building to left, and finally the white building, which was done with the absolute minimum of indication. The moral: for sunniness leave plenty of white paper!

The lighted side of a tall building is usually not uniform in value from top to bottom, due to the effect of reflected light and varied contrasts of background. It is common to take advantage of this fact to draw attention where it is wanted by grading the value from dark at the top to light at the bottom or vice versa. In Illustration 5, the base of the building, resting on sunlit ground, is made darker, while the steeple is left white to stand out dazzlingly as the center of interest against the dark foliage. Between the two extremes, the gradation of tones seems wholly natural. The same principle holds true in Illustration 6, a city scene in which each of the tall buildings, whether in sunlight or shadow, is subtly graded from bottom to top. In the white tower, the gradation is accomplished simply by indicating more windows in the upper stories and none at all near the street.

If I seem insistent on starting with the dark values and working toward the lighter ones, it is because I have seen so many pale, washed-out pictures done with the timid reverse approach. It is well for the beginner to get used to putting in the strong darks first.

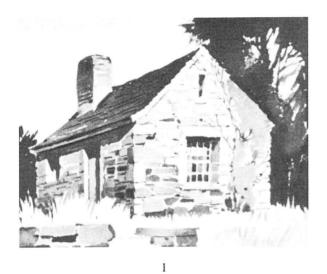

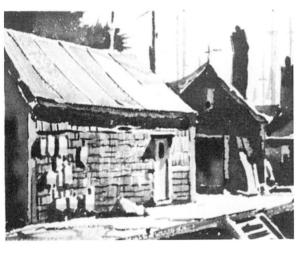

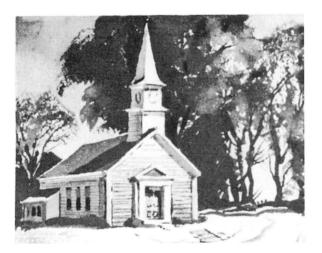

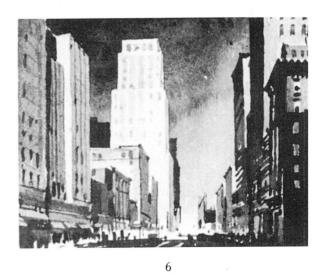

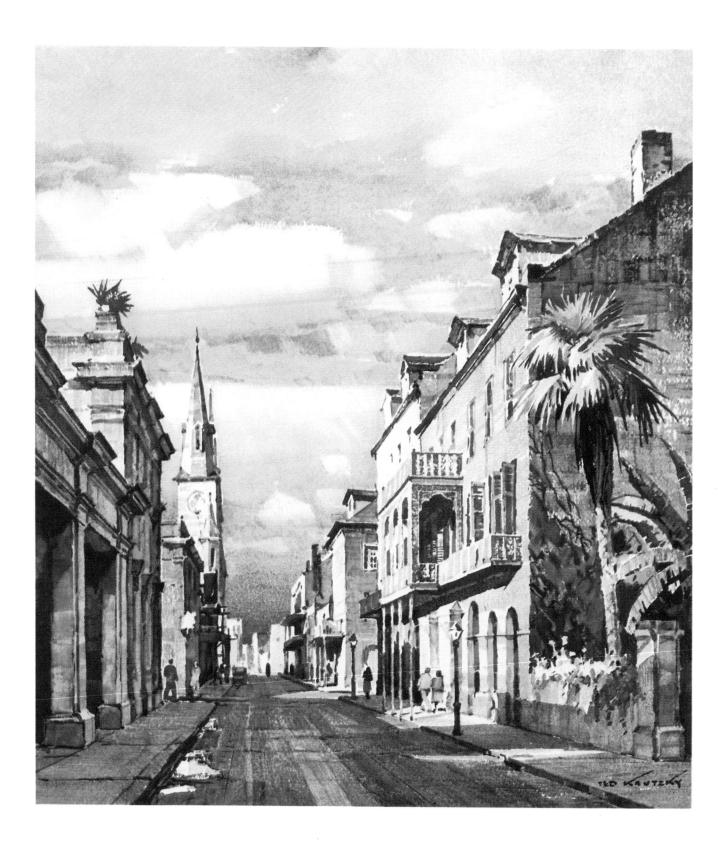

THE FRENCH QUARTER IN NEW ORLEANS

Size of original: 22" by 25". Painted on 300-pound D'Arches, medium-rough surface.

Palette: French Ultramarine Blue, Raw Sienna, Burnt Umber, Hooker's Green Number 2, Cadmium Yellow, Vermilion.

Order of painting: 1. The sky, carefully silhouetting sunny areas of buildings. 2. Shady sides of buildings on left and right, leaving palmetto tree and plants white paper. 3. The street. 4. The palmetto and plants at the right. 5. The sunlit façades of the buildings on the right and the sunny areas of the buildings on the left, modeling the church last. 6. The lamp posts and the figures on the sidewalks. Even clear skies constantly vary in value and color, from season to season, from day to day, from hour to hour. Not only that, but the same sky at any given moment shows gradations. Usually it is lighter near the horizon than higher up. Just to learn to paint *plain* skies with all the possible variations in color and to know what pigments to choose for different atmospheric effects will take you some time. The experienced painter rarely uses raw pure-blue pigment alone, no matter how clear the sky, for he knows that he can get more natural vibration in his color by mixing other colors with it.

When we come to clouds, the complexities seem to multiply. Form as well as color and value is introduced. But there is order in nature's ways, and no matter how infinite the possibilities, they all proceed according to certain laws of arrangement. If you will learn them, you will never paint skies that seem to be standing on edge or clouds that look as if they were cut out of cardboard.

Certain general observations will be helpful. The local color of clouds is stronger in the foreground —or rather the "fore-sky"—and their pattern is larger. Lower-level clouds cover higher-level clouds. Rows of clouds, which lie in horizontal layers, appear to be spaced closer together as they recede, and by accentuating this perspective effect you can get more depth in your picture. Gradation of value from near to far, with dark clouds in the fore-sky and light ones in the background, or vice versa, also helps to get depth. The edges of windswept clouds are soft; those of cumulus and cumulus-nimbus (thunderheads) are more definite.

Incidentally, you should learn the nomenclature of the different types, their characteristic forms, and their altitudes. They form and float normally at different levels, which are roughly grouped into high, middle (or *alto*), and low. Low clouds include *stratus* (found in a plain layer or sheet, usually quite low), *cumulus* (the summer, fair weather, woolly type), and *nimbus* (any cloud from which rain is falling). Combinations of these Latin names should be self-explanatory; for example, *nimbostratus*, *cumulo-nimbus*, or *strato-cumulus*. The bases of these low clouds are usually below 8,000 feet, but the warm upward currents which produce the *cumulus-nimbus* sometimes carry their heads up to 12,000 feet or more. Clouds whose bases lie above 8,000 feet are called *alto. Alto-stratus* is a layer cloud at middle levels, and it is usually lighter in value than the lower *stratus* types. *Alto-cumulus*, as its name implies, is merely a *cumulus* at middle levels, between 8,000 and 20,000 feet. Above 20,000 feet we find *cirrus* clouds, which are thin, fibrous, or feathery and may occur in small wispy patches (*cirrus*), layers or sheets (*cirro-stratus*), or ridges and rolls (*cirro-cumulus*). Learn to know and recognize these types. There are books which will tell you more.

In painting large skies I prefer to use very heavy paper or board, which will not buckle. When the structure has been roughed in with pencil, I wet the entire area evenly with sponge or large brush, then introduce the colors and paint the sky. The working surface is kept level, but tilted occasionally when I want the wash to run to indicate wind direction or movement. If the air is dry, as in a steam heated apartment, I add a little glycerin to my water to keep the wash wet. If it does dry out, and I want to add more clouds, I dampen the area again, using a wet brush lightly. I occasionally use a sponge for wiping out and modeling light clouds. For storm clouds, I find burnt umber, French blue, and Payne's gray a good combination.

In the six illustrations, which show different types of cloudy skies, I used the brush most, but in 1, 5, and 6 I used the sponge sparingly. For all of them I kept the surface wet throughout. In 1, we have cirrus clouds, flying very high: in 2, the subject is a mackerel sky of alto-cumulus clouds at about 10,000 feet. A high thunderhead, or cumulusnimbus, reaching possibly to 15,000 feet is shown at 3, and some dark low-flying cumulus-nimbus forms are ready to rain in picture number 4. Note that the successive rows are smaller and closer together here as they go into the distance. At 5 and 6 are a summer afternoon's cumulus clouds and rolls of high cirro-cumulus rippling across the morning sky. They all suggest the tremendous range of possible effects.

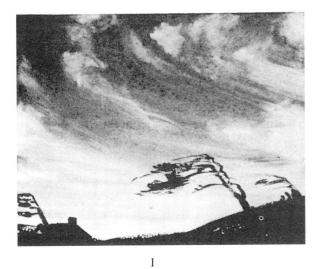

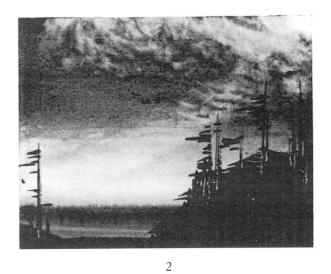

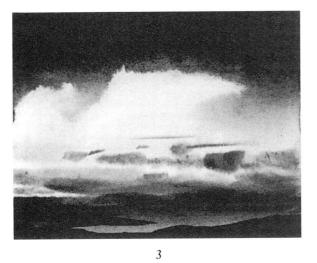

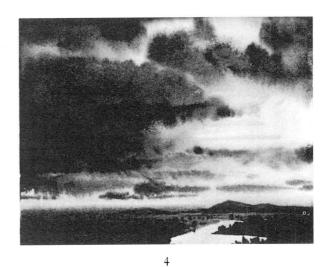

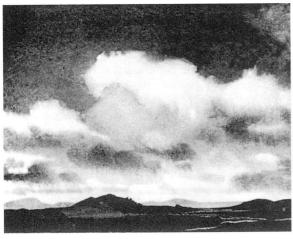

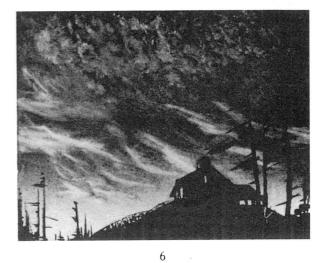

SKY, ROCKS, AND SEA

Size of original: 22" by 30". Painted on mounted Whatman, rough surface. Palette: Burnt Umber, French Ultramarine, Winsor Blue, Payne's Gray, Raw Sienna, Hooker's Green Number 2.

Order of painting: 1. Sky area wet with sponge and clouds painted in while wet, using umber, gray, sienna, and French blue pigments brushed in lightly and allowed to "bleed." Paper tilted as needed to control bleeding. 2. Water area (including strip of sky above horizon) wet and painted with not too wet brush, heavily loaded with mixture of two blues and a little umber, allowing color to bleed up into sky. 3. Dark distant rocks painted directly on dry paper with final values, in Winsor blue and umber mix. 4. Foreground rocks done with warm tones, using some carefully placed dry-brush strokes where glinting light strikes.

It hardly needs to be said that trees are highly important elements in the majority of landscape paintings. Therefore, the would-be painter must master the means and methods of depicting them with skill and precision. They are of such infinite variety of shape, size, color, and character that they lend themselves well to the purposeful creation of picture patterns. One must know thoroughly the distinguishing marks of the various species, their habits of growth, and their aspect at all seasons. This knowledge comes only with continued systematic observation.

In general, it is most important to have the structure right—the right relationships between trunk and limb and branch, between skeleton and crown. Then the leaf masses must be painted with strokes that express the movement and direction that follow natural growth for each species.

In Illustration 1, I made a picture out of some birches seen against a background of massed foliage and sky. The problem is to silhouette the trunks and branches cleanly and effectively, dark against light and light against dark. I painted first the background and the grassy foreground, using dry-brush strokes where I wanted to get shimmering sun. While the heavy wash was still wet, I knifed in the light trunks and branches, giving them interesting form in keeping with the nature of birches and avoiding the stiff perfection of symmetrical specimens. Then the continuation of trunks and branches against the sky were painted in with the brush, and modeling of the lighter silhouettes was done to indicate dark patches of bark here and there, at junctures of branch with trunk. Finally I painted the thin foliage, using dry-brush strokes with direction suggested by nature.

Another special method for painting birch trunks is shown in Illustration 2, this time against a light background. First the distant trees at the left were painted, leaving white paper for the three small birch trunks in sunshine. Then the three foreground trunks were done with one stroke for each, using a flat, square-ended brush, wet first with clear water and then well loaded on one side with rich pigment of the desired color. As each stroke was made with the brush thus prepared, the color tended to spread across into the clear water, producing a gradation highly naturalistic to the rounded birch trunk, as you can see. This is a useful stroke to master, so practice it. The details were painted later and the dark tree at the right and the foreground grass came last.

The elm tree, which dominates Illustration 3, is presented to emphasize the importance of graceful structure, foliage direction, and leafy indication. When I paint such a tree, I carefully sketch out the trunk and principal limbs and the main foliage masses, giving them form and direction. Then I paint the foliage with plenty of rich pigment in my brush, holding it upright for the solid central portions but flatwise for the lacy edges of the silhouette. The rough surface of the paper lends itself beautifully to this technique. The trunk, limbs, and branches can be painted in while part of the foliage is still wet, care being taken to make them taper naturally toward the top. The silhouette gives the character.

In Winter, when trees are leafless, the trunks and limbs, branching ultimately into small twigs, can still identify the species. In Illustration 4, there are two fairly close-up views of the trunks and a more distant silhouette of the whole tree. After making a rough pencil outline of the nearer trunks and branches, I painted them with the desired color, modeling them with brush strokes well enough for reasonable naturalism. Then, while the big dark washes were still wet, or in some cases after rewetting them, I used the knife to model further, squeezing out the paint to simulate the effect of reflected lights striking the rounded corrugations of the bark. You can see how effective this treatment was. The background trees were painted quickly; first the trunks, then the branches, and finally the lacy masses of fine twigs done with dry-brush strokes having definite direction.

The last two pictures show how useful knife strokes can be to portray, as in 5, the effect of lighter trunks and branches against the dense darkness of the woods beyond, or, as in 6, young birches standing out among a solid mass of hillside pines.

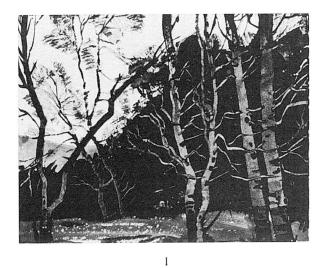

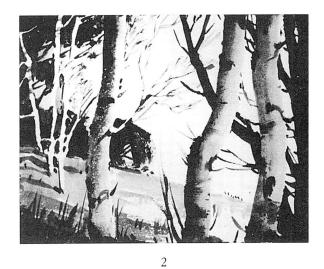

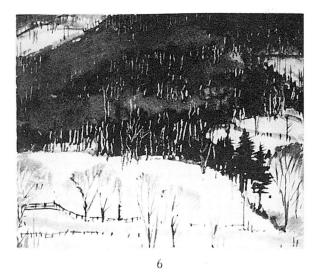

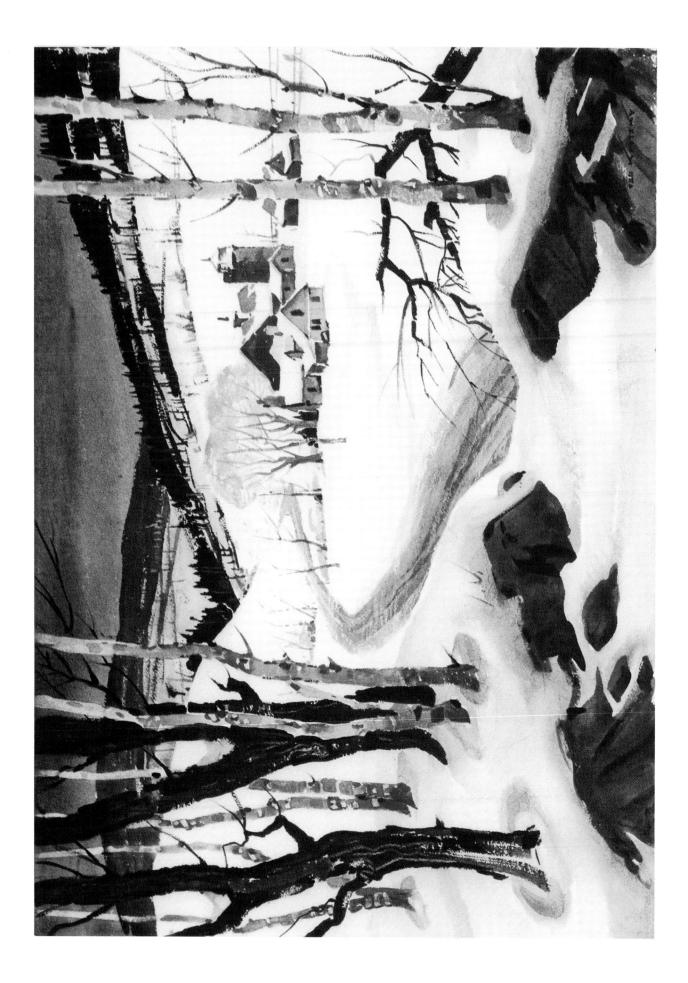

WINTER IN VERMONT

Size of original: 22" by 30". Painted on mounted Whatman, rough surface. Palette: French Blue, Burnt Umber, Hooker's Green Number 2, Raw Sienna, Alizarin Crimson (used only on barn and silo; could have been omitted). Order of painting: 1. Sky. 2. Background hill. 3. Pine forest. 4. Foreground dark tree trunks and branches. 5. Birches; wiped out over darks and painted over light areas. 6. Rock outcroppings and foreground snow. 7. The winding road. 8. The farm buildings and their neighboring trees. 9. Middleground snow left white paper; slight tint over background snow to make it recede into distance.

 $V_{2,n}$

We painters like terrain that gives us curves and angles and slopes from which to build our designs. Hills have softly rounded contours; mountains with forests have stronger, more sweeping contours; mountains with high rocky crests have aggressive angular silhouettes. Along coastlines we find less lofty but no less geometric rocky forms in the ledges, which have sharp corners and angular shapes above the high watermark and more rounded ones between the tide levels. All these departures from the horizontal have interested painters of all times as subject matter for their pictures.

Whether it is mountains, hills, or rocks, the first thing we will observe is that the forms of the masses are the important things—details are secondary. Also, we recognize that we must somehow express their qualities of solidity and weight—and in the case of the mountains their utter immensity. We must literally *feel* their weight as we paint.

One way of making the mountains seem larger and higher is to reduce the sky area above them in our pictures. The atmospheric effect of distance, whereby receding heights as they go away from us lose their local color and merge more and more into the sky around them, can also be turned to our account in accentuating vastness. Perhaps we can understand the phenomenon better if we think of air, which in small quantities appears colorless, as really being blue when we look through a sufficiently thick layer. This would explain the blueness of the sky, as well as the bluish tinge of objects from which we are separated by several miles of atmosphere. Anyhow, we can use the principle and leave the explanation to the scientists.

In our first picture, I used several means to produce an illusion of depth to make my mountain seem distant and vast. The converging curves of the road sweep rapidly toward the low horizon. The contrast in scale between foreground trees and buildings sets the buildings far back, then the successive hills beyond push the mountain back even farther, as it rises majestically and crowds the sky against the top of the picture. The sky is overcast, and I have made the hills and mountains become progressively lighter as they recede, with values that approach nearer and nearer to the sky value. There can be no question about the magnitude of the last mountain or its distance—yet it occupies but a fraction of our picture area! Had the sky been sunny and clear, I would have followed the same principle and made my mountains bluer and paler as they approached the distant sky, thus securing the same effect of remoteness and size.

In Illustration 2, there is another mountain; this time light in value against a lighter sky and with a dark foreground. Here, distance is emphasized by giving the mountain no detail at all and letting the foreground elements stand out stark against the misty slopes beyond.

The rounded forms of low, rolling hills, modeled by the sunshine falling across them, can be painted simply with washes of gradated value; highlights, shadows, and reflected light define the shapes as they do in a bowl of fruit. But there is detail to be considered also, and that detail can be used not only to enrich the pattern of curving line but to emphasize and explain the underlying formation of the earth. Illustration 3 shows how thoughtful arrangement of the elements—the winding road with its border of trees, the furrows in the fields, fences, cloud shadows, and patches of green reaching out from the woods—can subtly stress the contours and profiles that help to model the hills.

Where rocky formations, great or small, stand shorn of any covering of soil due to the action of wind and water, their geological formation and structure may be useful to the painter in building up his effects. Advantage may be taken of the lines defining the rock strata to do several things. In 4, they helped me to express stability, weight, and form as I painted the towering crags with dry-brush strokes, darker at the base, lighter at the top, eliminating details for sunshine and sparkle. In 5 and 6, I used the parallel rock layers to lead the eye in perspective and to set up contrasting line and movement in my designs. Nature lent herself to my purpose of creating interest and focussing attention. She will be equally ready to cooperate with you.

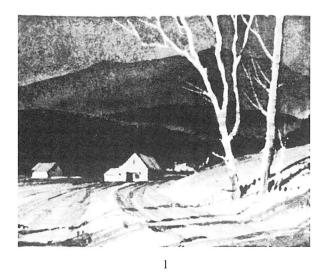

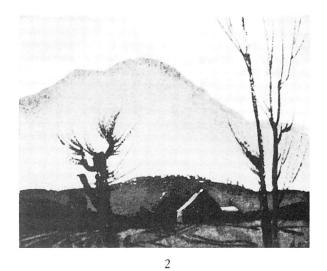

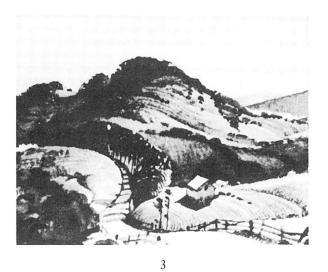

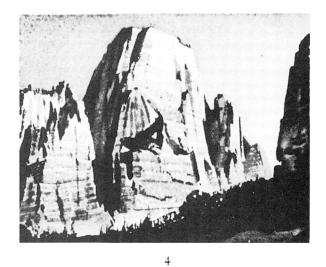

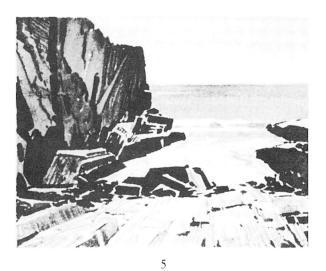

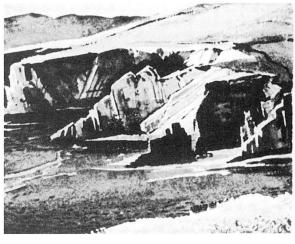

VIEW IN THE GREAT SMOKIES

Size of original: 22" by 25". Painted on D'Arches, 300-pound, medium-rough paper.

Palette: French Ultramarine Blue, Winsor Blue, Cadmium Yellow, Hooker's Green Number 2, Raw Sienna, Burnt Umber.

Order of painting: 1. The sky, leaving white paper for the main trunk of the tree and the branches edged with sunlight. 2. The mountains, again leaving the tree trunk white paper; the mountains were later qualified with a medium-value wash to emphasize the effect of shadows and great distance. 3. The line of dark trees in the middleground. 4. The shaded areas of the rocks. 5. The large tree, the foreground shrubs and the highlighted areas of the rocks.

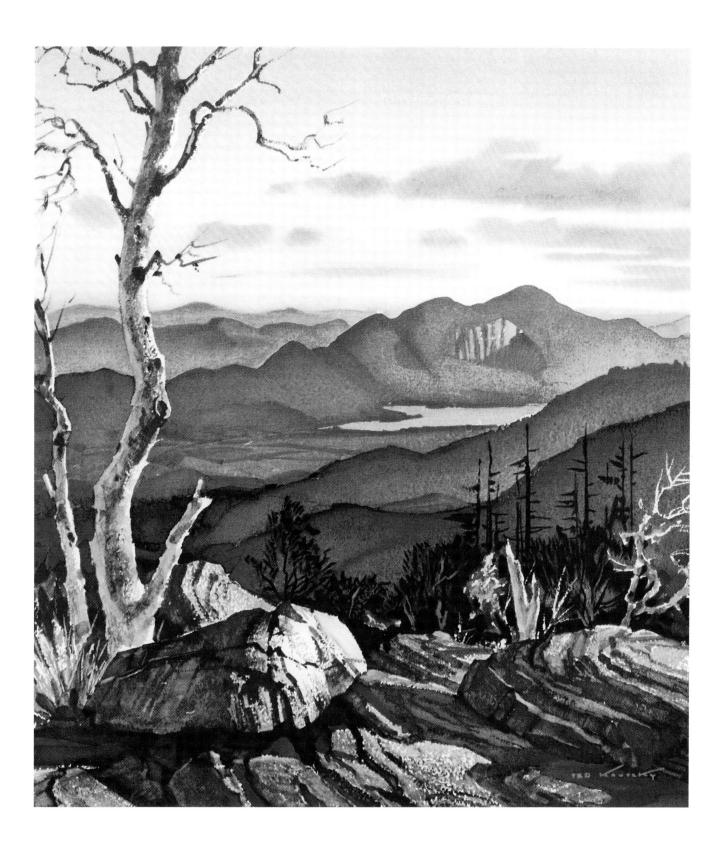

We encounter water in nature-paintable nature, that is-as puddles, brooks, rivers, ponds, lakes, and oceans. In all these forms it has much the same characteristics, so far as paintability is concerned. By itself it is colorless; the color it seems to have is made up partly of what we can see through it but mostly of what it reflects. Since it normally presents a level surface to the sky, its apparent color is always related to that of the sky. Clear, deep water, on a clear day, looks blue; when it is shallow and nearby, the same water takes part of its color from light reflected up from the bed it lies in-sand or rock or mud or seaweed or whatever. If the water is not clear, its actual color may be modified by its content of silt or algae-but it still gets most of its light from the sky and its *apparent* color principally from reflecting that light.

When we paint water, however, it is usually in conjunction with other objects—trees, grasses, rocks along the river bank; boats, wharves, ledges along the shore; etc. Reflections of these things, therefore, enter into many pictures more importantly than the water itself. Since the shapes of reflected objects are governed by the laws of reflections, we should learn something of these laws. I have illustrated some common applications on page 41.

Since I live near the sea, I have chosen some scenes in New England harbors or on the rocky, island-studded coast; they might just as well have been lakeside views or the banks of a river. The first two make a complementary pair, to show how the reflections of leaning objects-in this case the piles of an old wharf-differ from those of vertical ones. In 1, the piles lean to the left and towards the observer. Since the reflection of each point comes to the eye through a plane perpendicular to the reflecting surface, it is easy to understand that the reflection of the whole pile will also lean to the left. What may not be so easy, but is important to observe and remember, is that the reflections of things leaning towards the point of view extend out and become longer than the objects themselves appear in their foreshortened position. Conversely, in Illustration 2, where the piling slopes away from the observer, the reflections are shorter than the piles

themselves appear.

In both pictures, the water surface is made very light where it is far away and darker in the foreground. This is because out yonder it reflects the low, lighter part of the sky; while close to shore, where the wavelets appear bigger, they pick up the darker color from the sky above. Furthermore, with the greater angle of incidence (since we are looking *down* at it), the foreground water transmits some of the color of the bottom.

Looking out across a body of water, we are likely to notice that some parts of the surface are smooth while others are ruffled by wind. It is reflections that tell us which parts are rough and which smooth! Smooth water reflects the sky-mirrorlike: rough water picks up and relays to our eyes the light from many directions, either darker or lighter than the sky, depending on prevailing conditions. In 3, the sun is high and away from us, and the sky is blue. A smooth water surface would reflect only the sky, but the sea has been disturbed so that thousands of waves catch the glitter of the sun on their sloping surfaces and dazzle us with their combined reflections. We can paint this effect with dry-brush strokes. We observe, too, that darker streaks cross the brilliantly sparkling area and conclude rightly that these are patches of smoother water, which reflect the sky rather than the sun. We accentuate the perspective effect by painting these patches narrower and closer together as they recede. In 4, the conditions are different. The sky is dark overhead and a bright cloud lights up the distant sky. The smooth water reflects the cloud, and is left light, while the streaks of ripples pick up the sky color above them and seem darker.

The last two illustrations show how the reflections of boats, etc., are affected by the angle of sunlight. When the sun is high, as in 5, the reflection is lighter than the dark boat, since the water surface picks up some light from the sky above. When the sun is low, as in 6, and strikes full on the sides of the light boats, the reflections will be somewhat darker than the boats. This fact is worth remembering for future application when you visit the waterfront to paint.

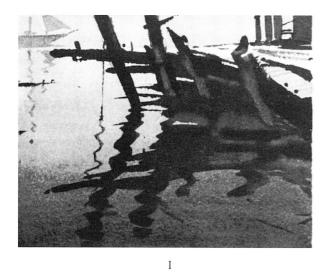

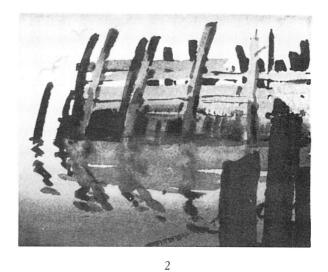

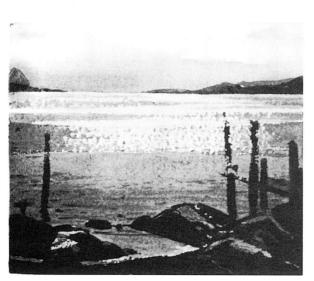

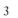

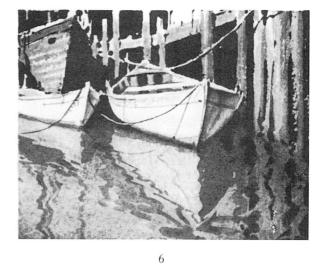

The average beginner, armed with a box full of pretty pigments, usually has trouble in restraining his inclination to use all of them in each picture. Oddly enough, using too many colors at first will slow down his progress in learning how to use them with full understanding of their possibilities. He will do much better to restrict himself to a limited palette at the outset, painting with one pigment until he has learned how to handle the brush in washes and strokes; then adding others to his repertoire, one by one, as he explores the possibilities of mixtures. If he does this, he will be pleasantly surprised at the range of effects he can get with two, then three, and later on, four pigments used together.

Of course, not all pairs of colors lend themselves to two-pigment painting, and one must choose colors that will suit the scene selected. Naturally, one will be cool and one warm, for distance and foreground. For my demonstration I used French ultramarine blue and burnt umber, two colors that I have found adaptable for a variety of subjects and capable of giving harmonious results, particularly for gray-day pictures-harbor scenes, snow scenes, city scenes, foggy scenes, wintry trees without foliage, etc. With these two pigments you can get blues, blue grays, grays, warm grays, gray browns, and browns-an excellent range for getting color perspective, with cool tones in the distance and warm ones in the earthy foreground. Many of the pictures I have exhibited were painted with these two colors. Both are permanent earth colors; they mix

well, make pleasing washes, and settle interestingly on rough paper. They will serve you well, when you learn to handle them.

For this lesson, if you wish to call it that, I have chosen two winter landscapes; one with the attention centered on the distant hills, the other built around a close-up view of a picturesque old barn. In the first, the distance is predominantly dark, with a light middleground and gray foreground; the other has its big dark values in the middleground barn, with lighter tones for the distance and grays distributed to give interest.

As I have said before (and will probably say again), I find it very helpful to make small, preliminary black-and-white pencil studies on white paper before starting to paint. These establish my design in line and value. I often do a number of studies before deciding on the final arrangement of my picture. Then the careful pencil outline on the final sheet can be drawn directly at large size with no need for stopping to make changes. And when I paint, my values are all predetermined so that I can focus my attention and energies on the colors and their spontaneous application with the brush. The pencil preliminaries for the two subjects under consideration are reproduced at the bottom of this page. These were drawn at a size of 4" by $5\frac{1}{2}$ ", a rectangle of the same proportions as the 15" by 22" sheets to be used for the paintings.

On the facing page, reproduced in black-andwhite, are half-completed versions of the final paintings. You can see both the order in which I

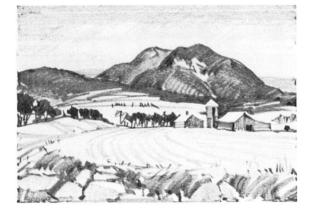

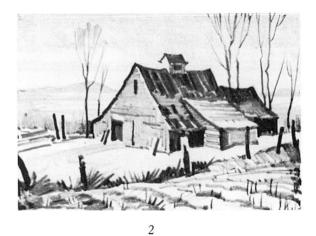

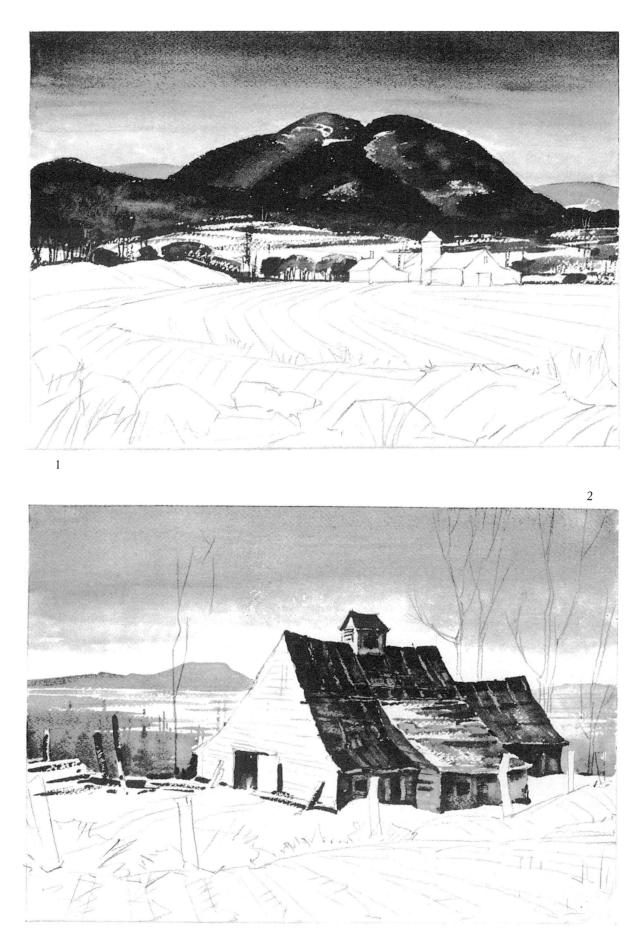

painted the different areas and the amount of pencil outline indication I used. The finished paintings are reproduced in color on page 47. I think you will judge them colorful enough, even though my palette was strictly limited!

In my book "Pencil Pictures," which you may or may not have seen, I discussed at some length the principles involved in designing pleasing pictures, and pointed out how the artist uses the elements of line and value in his subject matter to focus and hold attention where he wants it. Many pictures were analyzed in detail, so that the student could trace the thinking that went into their design. Here, I do not intend to dissect the composition of each picture, since the emphasis is mainly on technique. I will, however, point out the principal elements of arrangement in each case.

In both of the pictures that illustrate this lesson, the horizon is above the middle, and the points of greatest interest—the mountain and the barn—are a little to the right of center. The lines of the furrows, showing through the thin layer of snow, are calculated to lead the eye strongly toward the focus. Other lines—the rows of trees crossing the fields, the fence posts, tree trunks, and branches—contribute to this purpose and also keep the eye from escaping horizontally to right or left after it has reached the objective. The greatest contrasts in value occur respectively between the mountain and barn and their immediate environments. This much is not hard to follow. But let us get on with the painting!

In Picture 1, after I had drawn in my pencil outline to accord with the preliminary sketch, I started by painting the sky, first wetting the area with the brush, then introducing the color. Since the sky was to be overcast, and graded from dark at the top to light at the horizon, I needed to use only long horizontal strokes, laying the wash as described on page 20, starting with a warm mixture of the two pigments at the top and letting it get cooler and lighter below, ending up with clear water. When the sky wash was dry, I put in the gray-blue twin mountains, using mostly French blue with a little burnt umber to gray it, and leaving white patches on the slopes here and there to represent snow. The brush, not too wet, carried plenty of pigment and was used flatwise in defining the profile of the mountain against the sky, so that the edge would be rough and suggest the forested crest. The long low hill to the

left was then brushed in across the mountain base with heavy warm pigment, mostly burnt umber with a little blue added. While the brush was still fairly wet with this color, the middleground trees and the streaks of dark foliage against the distant snowy fields were painted with flatwise dry-brush strokes. Pale, slightly grayed blue was used for the distant hills, and the picture was at the halfway stage shown on page 43.

Next, I painted the furrowed field with burnt umber and a little blue, using carefully placed, drybrush strokes, which gave me the shimmering effect I wanted, to suggest the brown earth showing irregularly through the thin covering of snow. The foreground was done boldly, mostly with burnt umber, to indicate local color of the old boulders. Finally I painted the house, barn, and silo, using grayed ultramarine to contrast harmoniously with the dark brown of the neighboring trees and woods. I could not use the conventional red for the barn because of my limited palette. Since the value is the important thing, the result does not seem unusual. Pictures 1 and 2 are reproduced in color on page 47.

In Picture 2, the sky was painted in similar fashion, starting with a warm mixture at the top, blending into a cool gray and fading out to water at the horizon. Then, with a mixture predominantly blue in the brush, the distant mountains and intervening flat lands were put in, leaving patches of white paper for snow and finishing up this wash with warmer color in the middle foreground.

In doing this sky, I gave it a little more variety than the first one, letting the strokes simulate a few horizontal clouds. Because of my preliminary value sketches, I knew the trees could be painted in afterwards, so I disregarded them while laying the big sky wash and painting the mountains.

Now the big dark wash over the roof and shadow side of the barn was put in. I used a rich, juicy mixture, in which the colors grayed each other, to get the effect of old weatherbeaten wood and patched roofing. While the wash was wet, knife strokes were used on the roof to suggest detail. The lighter side of the barn was made warmer, with dry-brush strokes to give the texture of the old boards. Finally the foreground field was painted with plenty of burnt umber to give the rich local color of earth, faded grasses and weeds. The trees were quickly indicated with dark strokes.

Now that you know how the two-pigment pic-

tures were done, aren't you eager to try some of your own? To save you time, I have prepared some practice subjects for you.

PRACTICE SUBJECTS

If you have carefully followed in your mind the methods and steps I used in painting the two pictures just demonstrated, you are ready to try out your own skill. On the next page you will find two ready-made arrangements of subject matter similar to that used for the demonstration paintings. You can draw these at enlarged size on watercolor paper and go at them with your brushes and colors. It will be good practice.

My original pencil sketches for these, in case you are curious to know, were made 6'' by 9'', and I

have suggested enough detail so that you can paint, if you wish, on a 15" by 22" sheet. In the first picture, I have set the values, and consequently the mood, so you can use the two suggested pigments about as I used them in the painting you have just studied. In the second case, you will have to do a little more thinking.

First, decide for yourself on the kind of mood you want to depict, then make your own pencil study at about the size shown. You may choose a bright sunny day, with the sun striking the barn from right or left, from behind you or from in front. Or you may decide upon a rainy or snowy scene, with lowering cloudy sky. Select your values to suit, and put them in on your sketch, arranging them with an eye to making the design balance and focus attention where you want it. When it is satisfactory to you, go ahead and paint. I hope the painting suits you too.

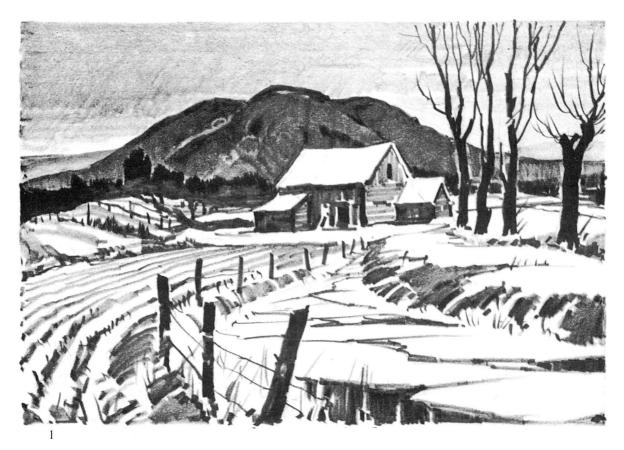

Above and below: Practice subjects. Facing page: Two-pigment demonstration paintings.

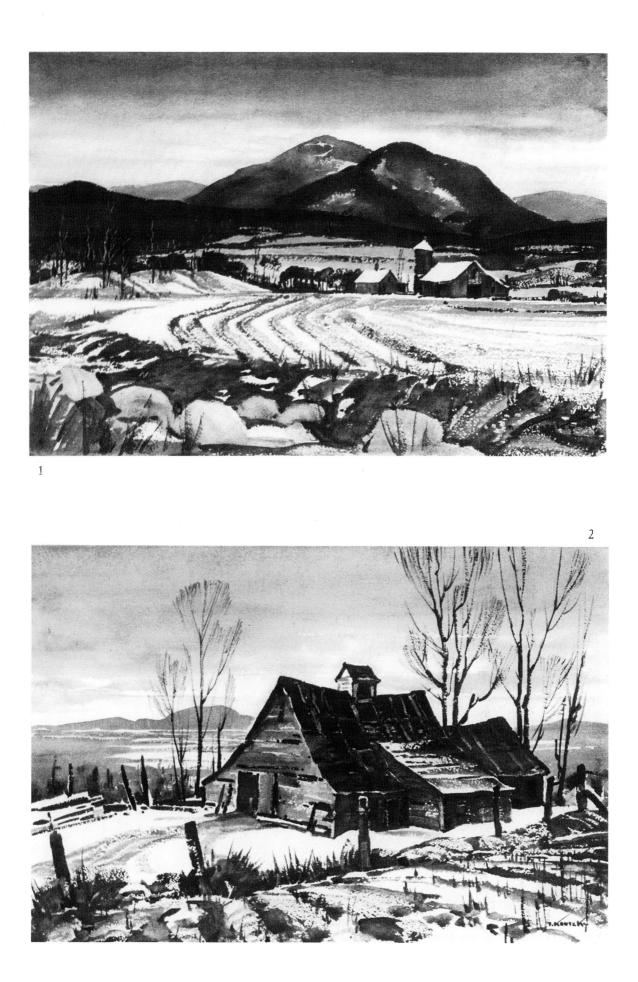

Perhaps you noticed, while experimenting with the ultramarine and burnt umber palette, that you could not introduce any green grass or foliage into your pictures. We will now broaden our palette by fifty percent so that we can increase our range of operations. Let's add a good fresh green—say Hooker's green number 2—to our blue and brown, and tackle some less wintry subjects.

As before, I have painted for you two different pictures as demonstration picces. They are reproduced in color on page 50. In the first, the subject called for more vivid yellow-greens than I could get by mixing the burnt umber with the green, so I substituted raw sienna for my brown pigment. The second was to be more somber, so I went back to the umber.

The preliminary pencil studies appear below. For the first, I selected a view from a position in a furrowed field, looking across a broken-down stone fence toward some farm buildings standing out against a distant mountain and a somewhat cloudy sky. The barns were to be my center of interest and, since they were in the middleground, I decided that a large sky area was needed to offset the weight of the large-scale foreground detail. That meant a low horizon. Following my usual habit, I placed the barns a little off center, this time to the left, and sketched in the other elements of the picture in proper relation to them. I made the foreground stone fence take a soft undulating line, descending from left to right, and used the silhouette of the distant mountain as a counter movement, descending in gentle curves from right to left. I reinforced this directional movement with the cloud formations. In opposition to the horizontality of these curves I put in some vertical trees in the foreground, both left and right, to help hold the attention on the buildings and keep the eye from wandering out of the picture. For value distribution I decided upon a dark foreground and a lighter background to give distance, with the strongest light falling on the barns themselves and touching the intervening field. Parenthetically, it is worth noting here that one of the things that attract you to buildings in a landscape is the pleasing contrast of their geometrical forms with the curves of nature. It is fair to emphasize this contrast as one means of compelling attention.

In composing Picture 2, whose principal subject was to be the snow-covered mountain, I followed much the same procedure. The glistening snow area forms the center of interest, placed a little to the right of the vertical axis and slightly above the horizontal one. This brings about a low horizon and a large sky in relation to the level foreground. The curves of the mountain and the middleground hill slope down from right to left, so I made the movement of the cloud formation downward from left to

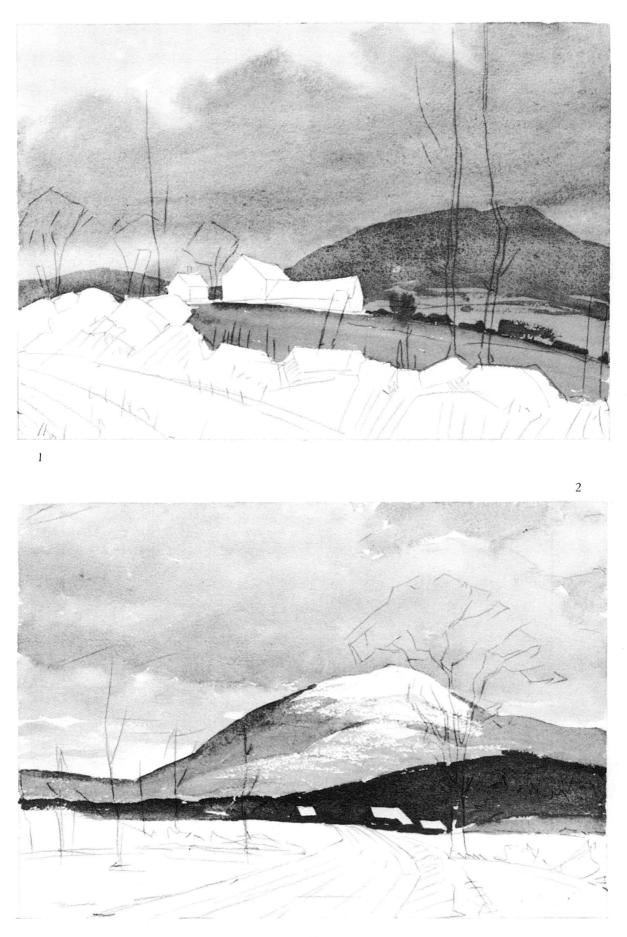

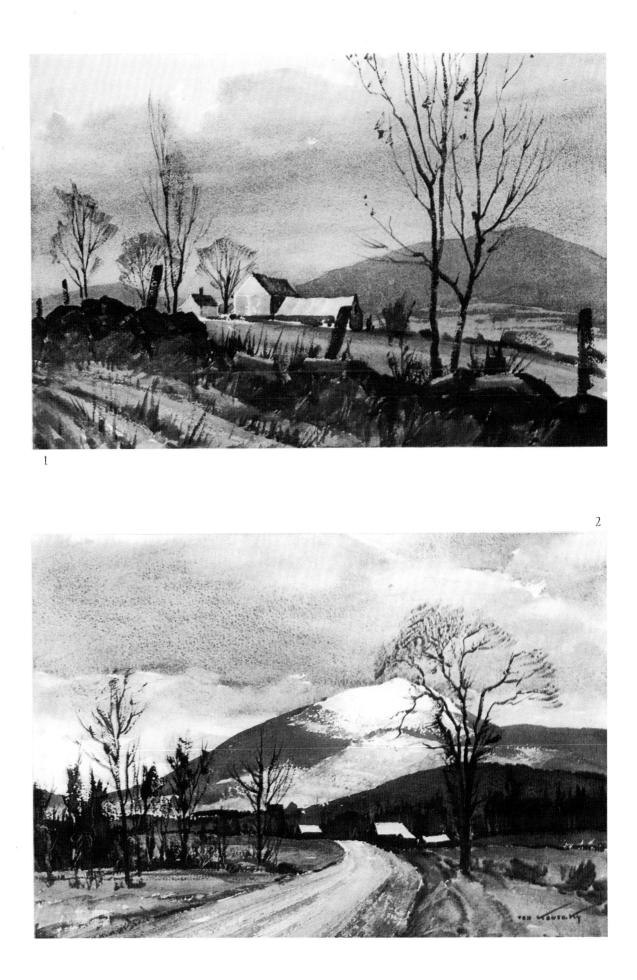

right as a balancing influence. The curved road entering the picture from the foreground contributes its powerful vanishing perspective lines to give rapid depth and lead the glance directly towards our intended goal, its course leaping up and over the dark middleground hill via the small but important shining rooftops. The low hill provides the dark contrasting note which makes the snow beyond appear more brilliantly lighted, and the deep grayed flanks of the mountain buttress this effect from either side. But some vertical accents are needed, as may be seen by glancing back at the half finished stage of my painting, overleaf, which just happens to have stopped short of putting in the trees. Comparing this with the preliminary sketch, you will see at once why the trees were added; they counteract the out-flowing horizontals and give distance to the mountain. So much for the design.

In painting Picture 1, the sky was done first, using a mixture of raw sienna and French blue and applying the color with direct full brush strokes on the dry paper surface. In this case, I did not previously wet the paper. Beginning at the top left corner, there was more raw sienna in the mixture, but as the wash progressed, plenty of blue was introduced in the clouds. You can see on page 50 how the proportions of the two colors varied as they were mingled through the sky area. This big wash was carried right down to the horizon, disregarding the mountains but painting around the silhouette of the house and barn, ending with a warm mixture carried across the distant field down to the row of bushes. The mountains were then put in as a superimposed wash, mostly blue, and the middleground field was painted in proper value, using the raw sienna with the Hooker's green. At this point the picture looked as suggested by the black and white reproduction at the top of page 49. (Incidentally, the half-way stages shown throughout this book were repainted after the entire painting in each case had been completed. This I had to do because it was not convenient to stop in the middle of each subject to have photographs taken for reproduction. I mention the matter lest you detect some slight differences between the washes and delineation in the half done versions and the finals. These differences are unimportant, but they might cause you some puzzlement if you did not know the reason for them. I would not want you to be worried!)

Returning now to Painting 1, the next step was to paint the stone fence and the foreground field. French blue and raw sienna were used for this, with plenty of the blue to give the dark values required for the stones. I used knife strokes, as you may notice, to model the stones while the wash was still wet, and a fairly dry brush for the grasses and weeds. The fenceposts and trees were done with a strong, dark, pigment mixture and finally the buildings at the point of interest were painted with a minimum of detail and with a bit of white paper left for sparkle.

The White Mountain scene, which forms Picture 2, was begun with the sky painted directly on a dry surface. Burnt umber and French blue were the pigments this time. They were mingled with the brush fairly full as I modeled the big cloud, leaving a few bits of white paper to suggest touches of sun hitting its upper edges. Of course, I used care in following the profile of the mountain top, for its silhouette is important to its identity. The sky wash, as before, ended very light at the bottom. When it was dry, the darker slopes of the mountain itself were painted with blue to which a little umber was added to gray it a bit. Dry-brush strokes were pulled lightly across the edges of the snowy areas to simulate the effect of trees showing through.

The low middleground hill was painted next with a heavy mixture of the blue and brown, care being taken to paint cleanly around the wet roof tops, which were left white paper. More umber was used towards the base of the hill to make its lower slope come forward. The fields were done with green, grayed with umber, and the road with blue toned down the same way. Some dry-brush strokes suggested the marks left by traffic. Finally the trees and bushes were added, mostly with umber, and a few knife strokes served to model the trunks.

Thus, our second experiment with the limited palette has ended, happily I think. You have seen how other moods of nature can be handled with few colors and have, perhaps, observed how this treatment helps to maintain a feeling of unity throughout our pictures—the same pigments permeating the whole fabric of the design. Now, before extending our palette still further, you may want to try your hand again, so I have prepared two more subjects for you to experiment with. You will find them on the next pages, all ready for you to make into paintings.

PRACTICE SUBJECTS

You have been watching over my shoulder, so to speak, while I have been painting hills and mountains, skies and fields, trees, rocks, buildings, etc., so now you should be able to apply what you have learned. Try it with these two ready-made subjects composed of the same elements. As before, the upper picture has the values and mood decided for you; the one below is for your own decisions. Enlarge these scenes in watercolor or substitute others of your own design. Better still, if you have time, do both. The important thing is for you to go to work and experiment to see what you can do with three pigments, gaining at the same time greater control over the tools of the trade. Later, you will be entirely on your own and will make, I hope, many original pictures.

I suggest that you work on sheets measuring about 15" by 22", penciling in your rough outline as you have seen me do and then proceeding with the color. For the second subject shown here you will, of course, first make your own small-scale preliminary, with the values all worked out. Let us suppose it is early spring, with snow still lying on the mountainside. The fields may still be brown from winter, but the green is creeping through them and the willow twigs are waking up and taking on a warm color. Blue sky, fluffy white clouds, shadows falling across the brook—can't you imagine it! Then do so! And make a record of your pleasant imaginings.

ROCKY SHORE

Size of original: 22" by 30". Painted on Royal Watercolor Society paper, medium-rough surface.

Palette: Cobalt Blue, French Ultramarine Blue, Burnt Umber, Raw Sienna, Hooker's Green Number 2.

Order of painting: 1. Rocky shoreline, starting at left and painting deepest shadow areas first; the gulls were left white paper. 2. The water, moving the brush in the same direction as the movement of the water. Note the use of drybrush strokes on both water and rocks. 3. Final modeling of rocky shore, and gull flying over the water.

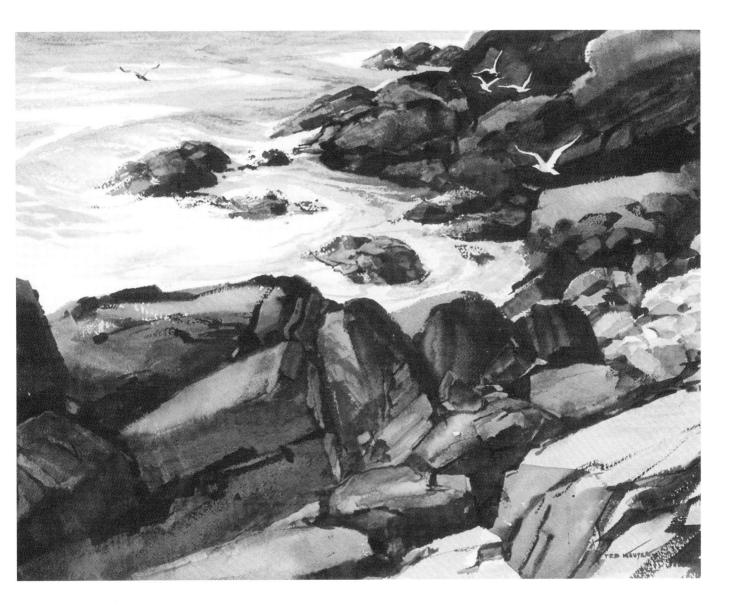

With the three pigments so far explored, we would not be able to paint correctly a New England autumn tree, a Vermont barn, a Virginia fox-hunt, or a Philadelphia fire-engine—or indeed anything containing red! Curiously enough, we haven't found the limitation too embarrassing up till now, and have managed to paint several sizeable hunks of landscape. Perhaps Nature is not as lavish with her reds as we might have supposed. She may keep this precious color for special occasions such as sunset clouds and poppy fields, scarlet oaks in October and rose gardens in June. So we had better use it sparingly too; but, anyway, let's add it to our palette of brown, blue, and green. The possibilities then become practically unlimited.

To demonstrate, I have chosen to paint two autumn landscapes, using for the first one raw sienna, Antwerp blue, Hooker's green number 2, and vermilion red. The raw sienna is lighter and yellower than the burnt umber and will, when mixed with red, give better tones of orange for the foliage. The Antwerp blue is grayer and less intense than the French ultramarine with which we have been painting, and will make the skies and mountains and shadows a little colder as befits the season. (For the second subject I substituted Winsor blue, which is deeper and even colder than the Antwerp; but I stuck to the other three pigments of our quartet.)

Here again, my pencil preliminary sketches are shown below. In Number 1, the weathered barn which was to be the focus of attention was first placed in the middleground with its pointed gable end slightly to the right of center, though its total mass extends to the left. A stone fence running along beside the foreground road introduced a strong irregular waving curve, descending from left to right across the picture and forming, with the road itself, a base of sufficiently interesting detail to give contrast and scale to the barn. To keep the line of the wall from leading the eye out to the left, a strong vertical was contrived by accenting the big tree trunk and giving its branches a general movement back toward the featured gable.

At the right, a tree with soft foliage masses was arranged as a foil against the geometric form of the building, with which it would contrast nicely. With the sun coming from the right, its shadow would also fall interestingly across the end of the barn. To break up this large shadow and give it even more play of light and dark, I introduced a small tree by the roadside so that it would catch the light and silhouette its branches against the corner of the barn, while at the same time throwing its own shadow across the road in a sloping direction, in opposition to the road's edge. A handy little tree, that!

The sky was made principally light so that it would contrast with the dark forms against it. But in the upper left corner a darker patch was made to slope up to the right, countering the movement below, and also serving as a subtle indication of the direction from which the light was coming. A few dark notes—the buildings at the left, the low distant hill, and the stone fence, which carries the horizontal line of the barn's base out to the right are important stabilizing influences in the picture.

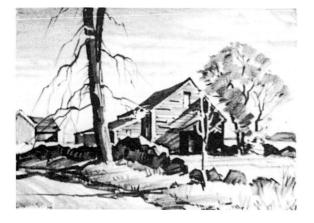

1

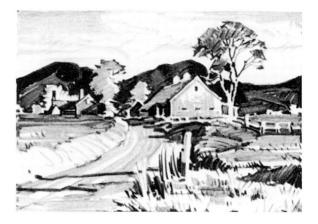

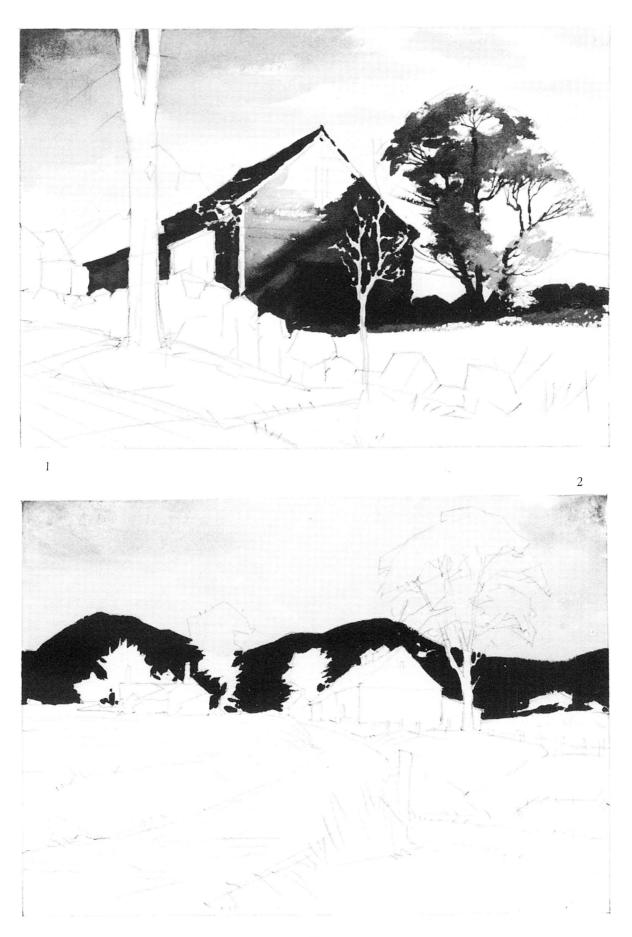

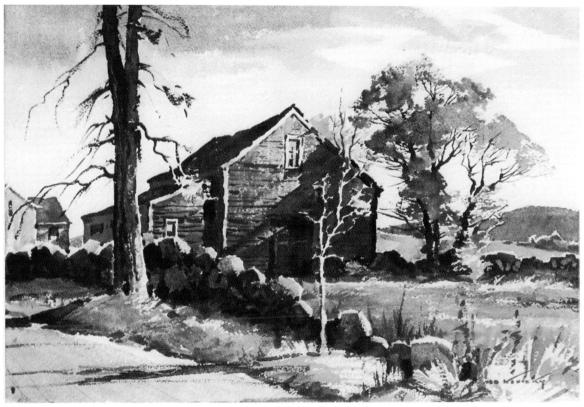

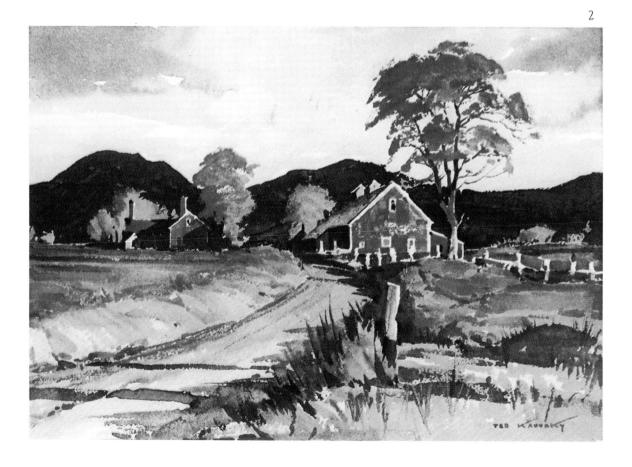

In painting this subject, I put the sky in first, directly on the dry paper surface, with strokes that modeled the clouds in their final values and forms. With this backdrop completed, I went to work on the principal darks—the barn roof and shady side of the barn, the big tree-shadow cast on the gable end and extending into the old stone wall; then the foliage and trunks and branches of the picturesque tree at the right. You should be able to discern from the color reproduction what pigments were mixed into the various washes, if you have profited from your experience thus far.

Moving now into the foreground, I next put in the big tree trunk and branches (using dry-brush strokes, as you can see, to get shimmering light effects where the sunshine struck the rough bark) and continued with the foreground wall, leaving white paper where the strong light hit the topmost stones. Only a few details were left—the road and its grassy border, the fields (in which I used some dry-brush strokes), the distant hill, and the small building beyond the barn. The colorful sunlit portion of the barn was done last, when I could tell easily just how far to carry it for the best effect.

I did not resort to the knife or do any wiping out of light areas in this picture. If you will look closely at the half-way stage, you will see that I painted around the places where I wanted to leave white paper—the little tree, the small patch of foliage on the low-hanging branch of the big tree, the corner boards of the barn, and the highlights on the stone wall. The washes involved were not too big and I had time to go around the whites without risking any drying out while I worked. The size of the picture was the same as the others, 15" by 22".

Picture 2 was designed to cover a broader territory, another barn forming the center of interest but placed farther back from the point of view. Its accompanying house, characteristically across the road, could then be included. In this instance I made an exception to my rule and placed the horizon midway between top and bottom of the picture area, but the range of hills extending across the view had the effect of raising it, so that there is no sense of having an unpleasant equal division of space. Light sky, dark background, gray middleground, and lighter foreground are well related to each other.

The curving road, leading in from the left, carries the eye directly to the barn. Secondary movements of line toward the same objective were provided by foreground details, roadside shadows, undulating fence, etc. The tall tree by the barn and the smaller one by the house help to frame the subject of our interest without seeming stiff. They belong there, and had they not been already in place I would have introduced them for purposes of building my picture arrangement.

Having established the arrangement and values, I pencilled in my principal lines on the final sheet and took to the brush. The sky was painted directly on dry paper as in Picture 1 of this pair, and then I put in the dark mountains with mostly Winsor blue grayed slightly. As you will note, I painted carefully around the trees and buildings, preserving their distinctive silhouettes. Then followed in order, the shady parts of the house and barn, the trees, the fields, and the road with the shadows among the grasses along its edge. The level parts of the fields were mostly greens, modified with sienna or blue here and there to modulate the tones. Along the embankment at the left, warm color was used to produce a light glow where the sun struck more directly. In the foliage of the trees, vermilion was mingled with the Hooker's green and raw sienna to get the rich autumn color, and nearly pure vermilion was used on the sunny part of the house. The last thing to be done was the sunlit face of the barn, where I used bright color, with vermilion and green carefully disposed to give the most interest at the most important point.

We have now gone through the process of painting with just a few pigments; two, three, and four having been successively experimented with. I hope that I have convinced you that a substantially wide range of subject matter can be satisfactorily painted without spreading out over the whole box. In the chapters that are to follow, we will add some other colors, but you will notice that I do so sparingly. I am most frequently content, both in the demonstrations and in the color plates throughout the book, to use only a few in any given picture. I believe that you will be well advised to follow this policy also, for it will give you a quality of color unity in your pictures as well as enabling you to learn the characteristics of each pigment thoroughly as you add it to your vocabulary.

But first, here are practice subjects with which to make your first trials of the four-color palette. Happy painting!

PRACTICE SUBJECTS

Since we've already gone through this a couple of times, it's hardly necessary for me to tell you again what to do about the two pictures laid out in pencil on the opposite page. As you look at the top one now, I can just see you speculating as to what colors you are going to use for the different parts and which wash you are going to apply first! I know you can make a pleasant blending of the four pigments you choose and that you will finish up with a picture you will like, even if your brush work is not yet quite up to professional standards. Just be sure that your values are right in each area and you cannot go far wrong.

When you make your preliminary value study for the second arrangement, let your imagination play around a bit in determining the time of day and the kind of day you will depict. It might be early morning, with bright slanting rays of sunlight pouring in from right or left, striking the bright spots of foliage and giving you nice long shadows. Or it might be a blustering day, with a dark stormy sky silhouetting the forms and a mournful hint of rainy weather ahead. The color may be bright and vivid, or somber in mood. It is your choice. The results will vary according to your decisions. When you have finished, you will have learned from your mistakes and may wish to experiment further. I strongly urge that you feel completely at home with your limited palettes before adding more pigments.

With this in mind, two additional practice subjects have been added. On page 64 you will find another pencil value-study and on page 65 a blackand-white reproduction of a finished color painting. See what you can do with these without a single suggestion from me. After you have completed these extras, you will probably feel quite confident in your mastery of the four-pigment palette.

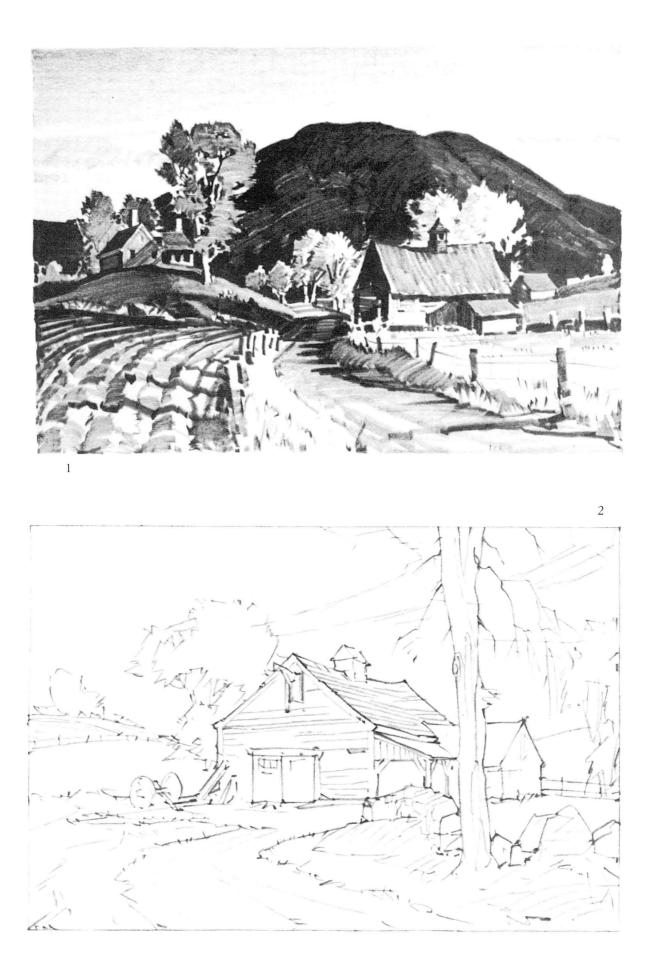

LATE FALL IN VERMONT

Size of original: 22" by 30". Painted on 300-pound Whatman, rough surface. *Palette:* French Ultramarine Blue, Aureolin Yellow, Hooker's Green Number 2, Burnt Umber, Davy's Gray.

Order of painting: 1. Sky, graded from left to right, with darker wash to indicate hazy background hill and the last house on the road. 2. Trees, starting with the dark tree at the left, and the dark middleground areas. The middleground tree trunk was modeled by wiping, and the small tree branches were done with drybrush strokes. 3. The buildings, grading the values from dark in the background to light. 4. The grassy flatland. 5. The road, using a middle-value wash and leaving white paper for the puddles and for the road area where the highlight is the strongest. The texture was superimposed, using darker values and dry-brush strokes. 6. The dark, water reflections. Notice how the size and shape of the puddles and the direction of the strokes at the bottom-left contribute strongly to the feeling of perspective.

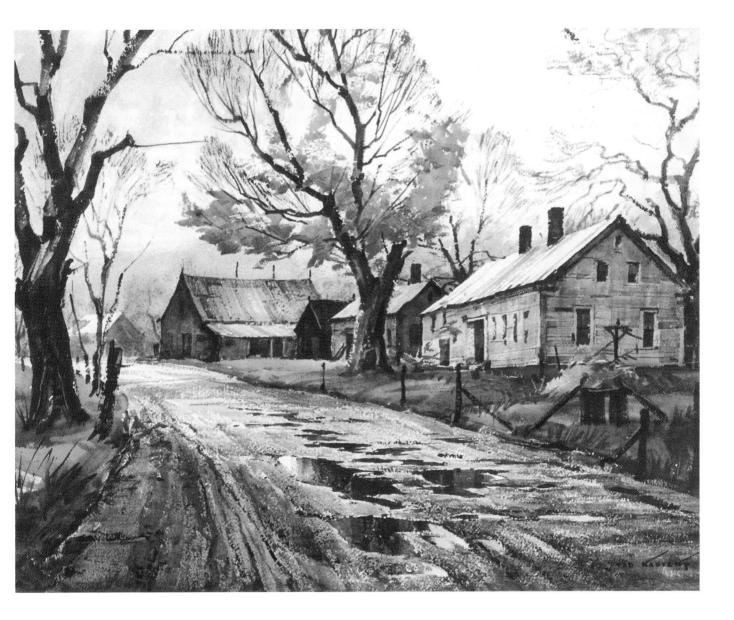

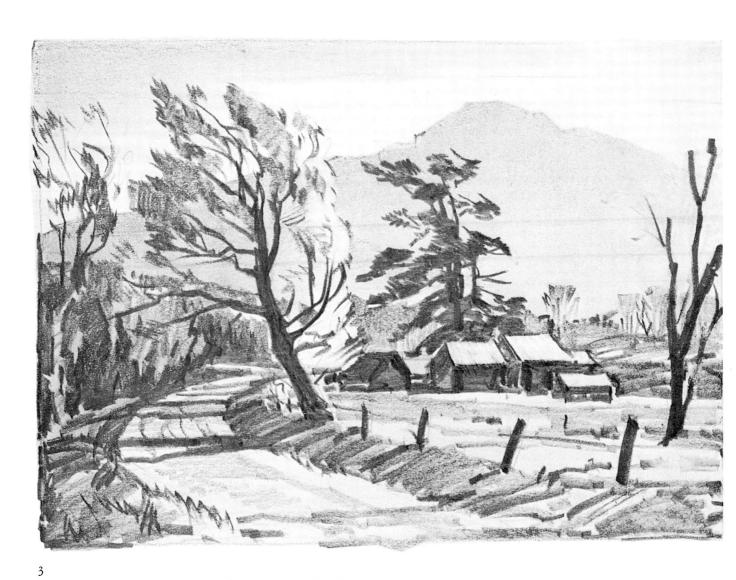

A preliminary sketch for four-color practice.

Back Road. Four-color practice subject reproduced from a finished painting.

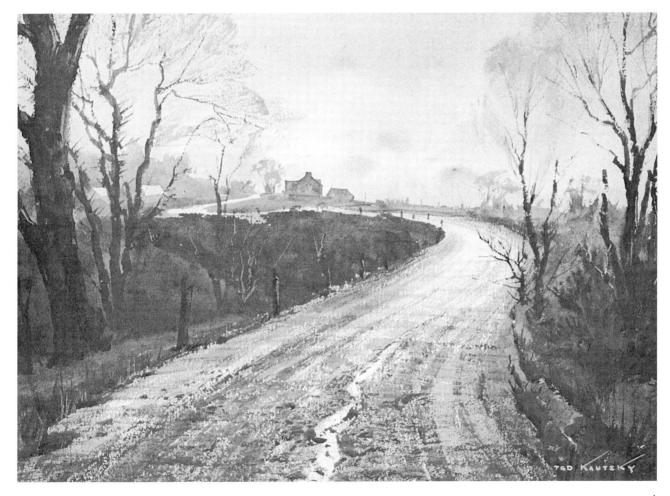

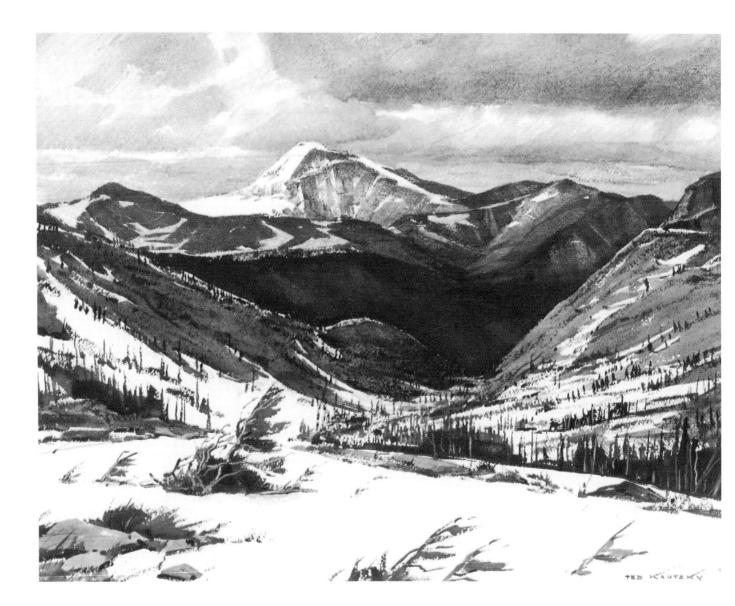

ALONG THE TRAIL-RIDGE DRIVE, COLORADO

Size of original: 22" by 30". Painted on D'Arches 300-pound paper, medium-rough surface.

Palette: French Ultramarine Blue, Burnt Sienna, Raw Umber, Hooker's Green Number 2.

Order of painting: 1. The sky. 2. The mountains; the modeling of the snowcovered peak was done later. 3. The foothills. 4. The evergreens scattered over the foothills and the dark accents in the foreground. 5. The foreground shrubs and rocks and final modeling of the snow-covered peak.

THE WINTER LANDSCAPE

The snow that comes in winter to carpet the hillsides, fields, and rooftops, touches every projecting form with fantastically modeled layers of white icing and brings interesting new problems for the painter. Its superficial whiteness makes it a perfect reflector of light falling upon it from any direction, so that under varying conditions of sky and clouds and sunshine it becomes almost alive with subtly changing modulations of delicate color. To paint it well requires keen observation.

The warm glow of reflected sunlight brings tinges of yellow, paler at midday, more golden at sunrise and sunset; the blueness of the sky is caught in the shadows, where direct rays of the sun do not reach and the contrast of cool and warm color seems to intensify them both. If the sky is overcast, so that no sunlight gets through, the surface of the snow will be a coolish white, or, if the clouds are dark, a delicate gray. Local color in sunlit trees or buildings will reflect onto the snow, modifying its color, particularly in shadows. You must look with seeing eyes if you are to catch its infinite gradations. There are painters who have given it lifelong study, an indication of its fascination and complexity.

The white of your paper, which is really not white at all but a delicate off-white, probably warm in tone, will count heavily in your pictures. Many times you can leave it untouched; at other times you will veil it with a slight tinge of cool blue or warm yellow, to suit the conditions. The texture of snowy surfaces is usually smooth, but it is often broken up and discontinuous where underlying grasses and stony earth show through. The dry-brush strokes will be convenient for expressing this, as well as for places where the snow clings thinly to the limbs and trunks of trees. In winter, perhaps more than in summer, there are greater extremes of atmospheric conditions. When the air is clear it seems exceptionally so, and the outlines of distant objects show up sharp and crisp. When the air is moist and misty, the contours are softer and more indefinite. These are generalities; now let's get specific.

I have prepared a lesson illustrated with two pictures. The preliminary pencil studies for value and arrangement, which were drawn at 4" by $5\frac{1}{2}$ ", are shown below. The first is a village street scene, with a mountain in the background. Actually, the mountain was not there; I put it in to help the composition. The spire of the church was obviously a strong element for my center of interest, so I put it slightly off the geometric axis. The other buildings took their places naturally and I emphasized their gables and chimneys selectively, stressing the lines and planes that would lead and hold the attention where I wanted it. To counteract their angular straightness, I introduced the curving swing of the road and the rounded forms of the mountain, which also provided a dark backdrop against which to silhouette the church tower. The tree to the left frames the spire and balances the building at the extreme

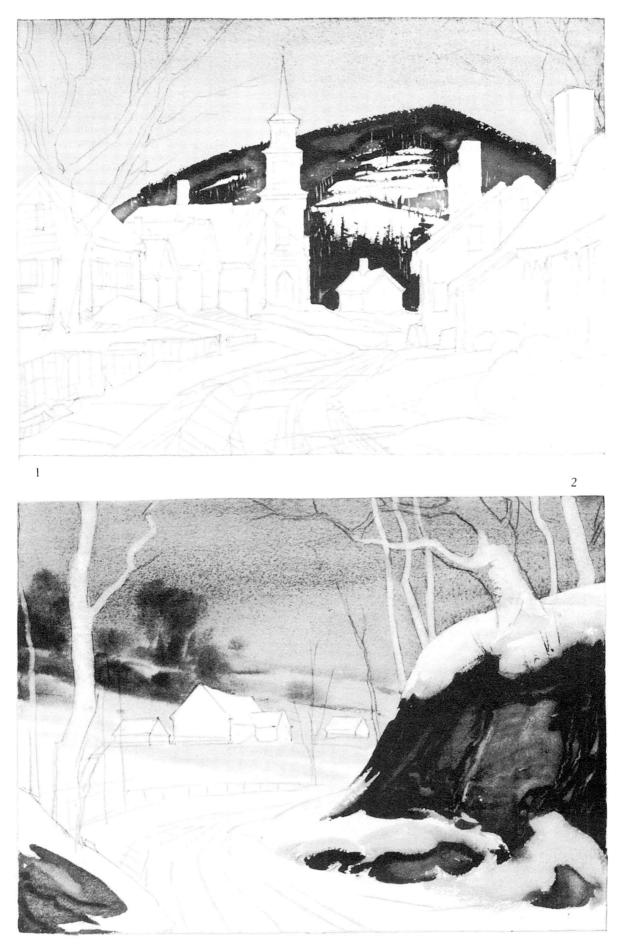

right. A few overhanging limbs on that side complete the enclosing arch and soften the angular corner. The values are distributed for balance and interest.

In the half-finished stage of this picture, which is reproduced on page 69, you can see how carefully the pencil outline was drawn and how much detail was defined as a guide for the painting. The sheet this time was 22" by 30". Since the sky was to be light, with things to be silhouetted against it, I painted it first, disregarding the tree limbs and the pyramidal top of the steeple. I wet the entire sky with clean water in the large brush, and then painted my wash with horizontal strokes, grading it from darker at the top and left to lighter at the bottom and right, to suggest that the light was falling from the left. Some warm color was used with the blue to give a hint of cloud above the mountain catching light from the warm sun. When the sky wash was dry, I did the mountain, using blue and brown for the wooded slopes and leaving the snow patches white, to be veiled and given distance with blue later, when the first wash on the mountain had dried.

Now I turned to the houses, painting their shadowed sides first and then the lighter values, but leaving the church to be done at the last, after all the other values and colors had been established and it would be easier to determine just how far to go. The stone wall at the left was made warm in color, and gradually darker as it receded into the picture. Then, when I painted the big snow shadow extending from the left across the road I started at the middleground with cool, darker color and carried it with one wash into the foreground, mingling warm color with the cool and modeling the ruts in the road and the snowbank beside it to express the warm light reflected from the sunlit house at the right. A few patches of white paper were left where the sun hit the snow directly through the branches of a tree outside the picture, and the reflected light from these areas was taken into account under the eave of the house. At this stage I put in the trees, using a strong mixture of color applied heavily with dry-brush strokes and modeling the trunk with the knife. That left only the church and its shadow, which could be easily done in proper value relationship with the rest. The sunny tower was painted last, with a minimum of detail in order to leave it sunny. Study the painting of the snow in this picture to see how the warm and cool color is used to give the effects of both direct and reflected light.

The second winter picture is dramatic in its arrangement, with a powerful dark rock ledge dominating the foreground at the right and leading the eye through a succession of curving lines around the bend of a road where some trees force the eye back to the center of interest, occupied by a barn standing out clearly against the misty distance. The contrasts are vigorous and the line pattern compelling. The snow areas will give us a chance for some graphic modeling. We decide on another 22" by 30" sheet.

With the careful pencilled outline as a guide, we first wet the whole sky area, carrying it down to the silhouette of the barn buildings, for we want to produce a misty effect by painting the woods and background trees right into the wet wash. Technically, this is difficult, but we will try. Using a warm mixture of partly settling pigments, we begin at the top and bring the wash down slightly cooler toward the crest of the hill, painting right over the outlined trunks of the foreground trees, and extending it into the areas where there is to be misty foliage. While these areas are still wet, we paint into them quickly the forms of the trees and bushes, using a less wet brush dipped in thick pigment of about the right value and color. If we have picked the right moment, and the wash is neither too wet nor too dry, we will find that the color will blur a little and blend around the edges with the surrounding areas, giving the effect you see. It might be well for you to practice the process several times on the back of an old watercolor before trying it on a final painting. You can get the hang of it if you are patient.

Now that we have the sky and background taken care of, we can turn to the big foreground dark of the rock, which we model with both brush and knife strokes to pick out reflected lights. We then wipe out the areas of the tree trunks so that we can repaint them and allow for some snow clinging to them. You can see where I used some dry-brush strokes as well as the knife in doing this. When the barn and farmhouse are done and the fence brushed in, we find nothing left but the snowy areas. Since the day is cloudy and misty, we use light washes of mostly warm gray to model the surface of the snow where it clings to the rocks and follows the wheel tracks of the road. We leave, however, plenty of white paper.

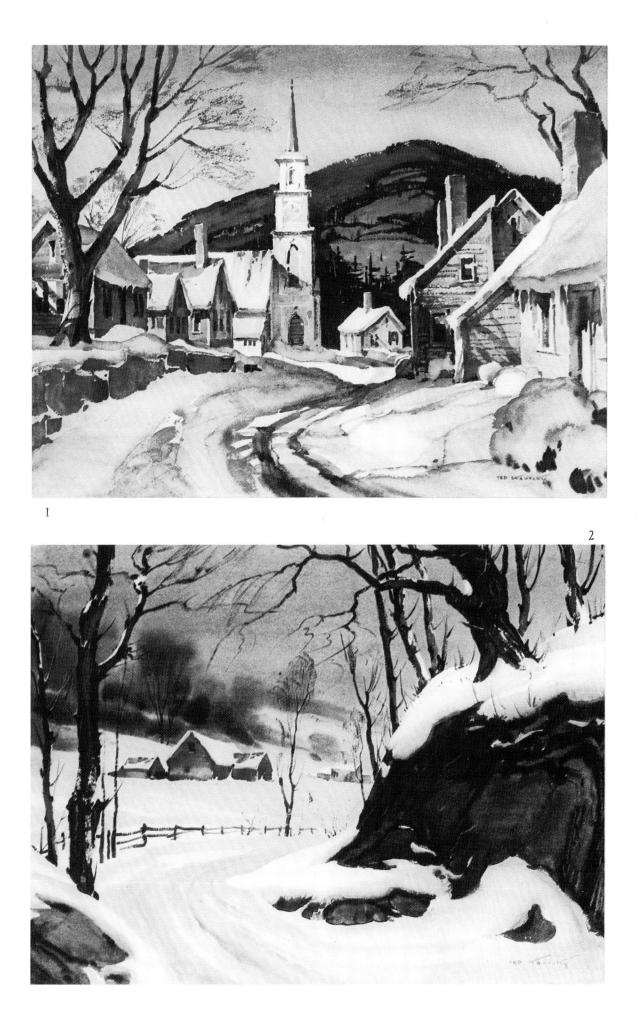

With the experience you have now accumulated, plus whatever you may have learned from following my progress through the two snow scenes just analyzed, you may now choose to make some paintings out of the pencil studies on page 73. The subject matter is not unfamiliar to you and you have presumably been painting similar elements in the earlier landscapes you have practiced. Now, however, you will deal with snow. If you will keep in mind the essentials of what I have just been telling you about its characteristics, you will not have too much trouble. A 15" by 22" sheet will be about right for the broad landscape, for it will give you room to maneuver your washes and the trees and other details will be large enough for convenient brush handling. So make your pencil outline and go ahead.

Picture 2 will again challenge your imagination. As I have outlined it, it may suggest a time of thaw, with sunlight striking in from the left at a fairly low angle to warm the snow and give luminous long shadows. Or you may boldly decide to try making a misty effect, with the indistinct outline of the background hill almost losing itself in the swirling storm while the foreground color (except for the snow) becomes low in key. Make up your mind what you prefer to do, draw your value sketch to correspond with the mood, and then paint.

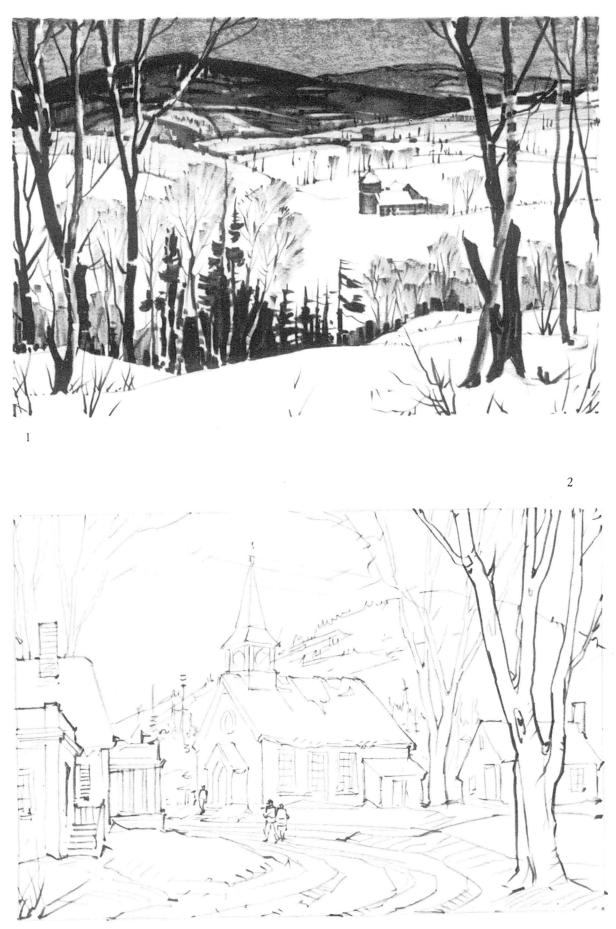

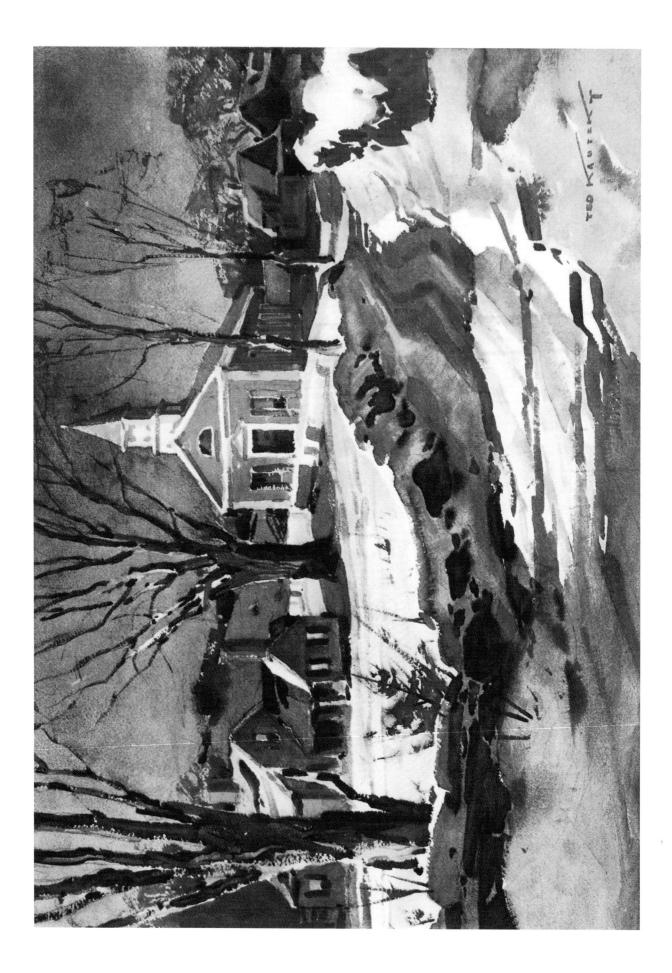

A COUNTRY CHURCH

Size of original: 22" by 30". Painted on 300-pound rough Whatman. Palette: French Ultramarine Blue, Winsor Blue, Burnt Umber, Raw Sienna, Hooker's Green Number 2, Vermilion.

Order of painting: 1. Ran sky wash on previously wet surface; painted around church but disregarded tree limbs. 2. Shady side of church and houses in back-ground. 3. Front of church, but not including steeple. 4. Big road shadow and dark stone wall at left, modeling for reflected lights. 5. House at left, trees in foreground and middleground, and shadows on snow. 6. Light glowing wash on snow surfaces hit by afternoon sun. 7. Church tower, done with minimum of indication for sunnines.

VILLAGE VISTAS

There is something about the conjunction of the soft curving forms of foliage laden trees with the geometric lines and planes of gabled houses that touches the heart and makes an instant appeal to the picture-minded person. Every old residential town that is blessed with a profusion of venerable greenery is a good hunting ground for the watercolor painter, for it is more than likely to be rich in composable material. New England is particularly fortunate with its villages of meandering streets lined with stately trees standing protectively among the usually well-proportioned houses. But there are many communities in other parts of the world that are equally inviting and have just as good picture possibilities. I happen to find New England more accessible and so I have chosen my subjects there, but the same principles of picture-building apply everywhere. The villages near you may be different in character, but if there are trees and buildings you can find the stuff out of which to design just as attractive a pattern as any I have devised.

In approaching the painting of a village scene, it is desirable to select a view that includes one particularly picturesque element—a house, a church, or some appealing building that can form the center of interest in your picture. The surrounding area should not be too busy with unrelated or distracting detail: if it is, you can subdue the irrelevancies and emphasize the focal feature by painting it in strong sunshine or with an interesting shadow falling upon it. For depth in your picture, it is well to be looking along a street at an angle, for in this way the perspective lines can be emphasized as desired, while at the same time you will have many tree shadows to give counter movement and break up any monotony. Do not feel that you must be photographically faithful to the existing architectural detail; omit windows if this is to the advantage of the picture, and do not try to paint every picket in a wooden fence. It is the masses that are important; the observer's imagination will supply the rest.

If, when you have laid out your design in the preliminary sketch, the scene looks unnaturally deserted, you can add human interest by introducing one or more figures. After all, the town is inhabited! But avoid using large figures in the foreground which become too prominent and are likely to steal the show by attracting attention away from the focal point.

When you are regarding the scene, the light may be falling from the most advantageous direction, but more than likely it will not—and anyhow, it will change while you sketch. For your picture, you can assume a condition that will give you some prominent shadows which can be used to lead the eye toward the center of interest. They do not need

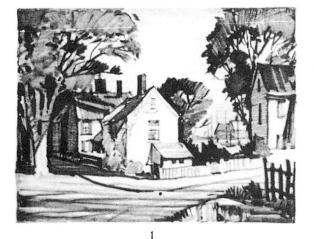

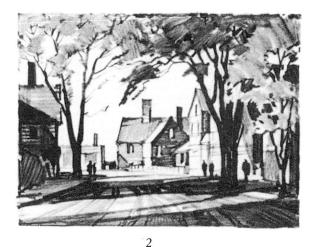

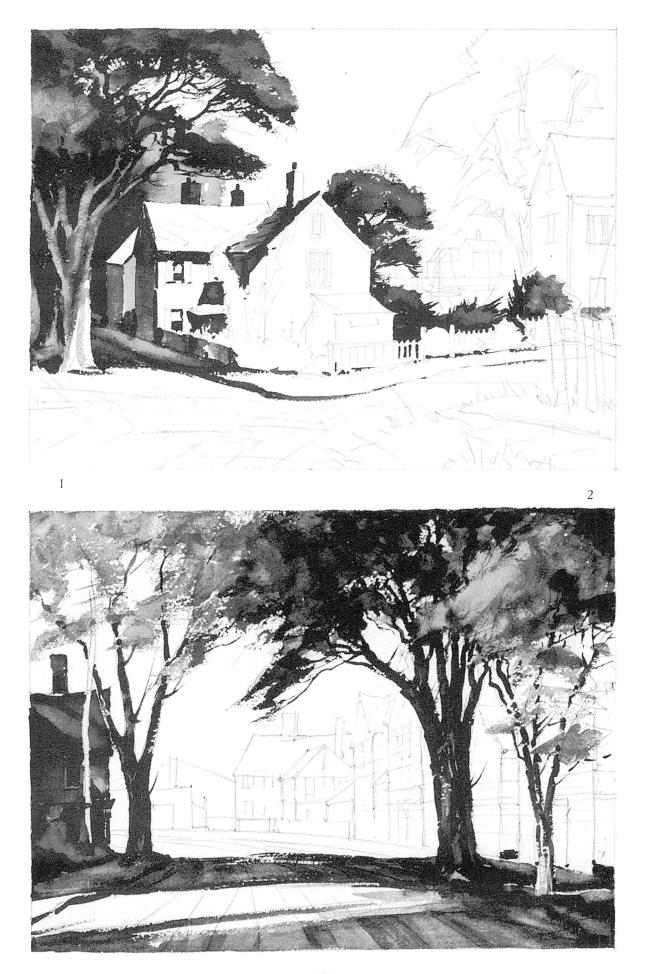

to point in straight lines to accomplish this; a more devious course may be just as compelling and it is not so stiff. Even a series of tree shadows running *across* the desired line of eye-travel may be so graduated and spaced as to exert insistent perspective pull. The sun-lighted areas throughout the picture will shine out more or less strongly according to the degree of contrast they are given, and you will naturally use this factor to direct attention. Do not fail to observe that the bright surfaces also reflect light into the shadows. This is particularly noticeable on buildings in the foreground, under the eaves, etc. Both value and color are thus modified.

The two watercolors I have used to demonstrate the foregoing points and principles were developed from the small preliminary pencil studies shown on page 76. I do not think I need to analyze their design for you. You can surely identify the center of interest in each and perceive the means that were used to make it draw your attention. You see, you are already getting scientific about your art study!

Now let's follow through the painting. In Picture 1, I began with the big shady areas to the leftthe trees, the distant foliage, the chimneys and dark ends of the houses, and the shadowed street. I was careful to stop short of the place where I wanted to put a couple of small figures, leaving this area white for the moment. Then proceeding to the right of the focal feature, I put in the tree foliage and shrubbery against which the house's profile was silhouetted. The dark bushes were extended along behind the picket fence and I had arrived at the stage shown on page 77. You will notice that the edges of the tree foliage were made lacy with drybrush strokes and that the silhouettes of the shrubs were carefully done with expressive strokes following the direction of growth.

The tree at the right and the house beside it were then painted, with warm reflected light on the shaded side and under the eave. The foreground shadows of the road and the weed-grown bit of fence completed the darker parts of the surroundings and determined for me the values that would have to be used on the central house. I completed the roof of this house and painted the climbing vine, bringing it down into the shadowy area that silhouetted the two figures. The remaining minor areas of this house and the one next to it up the side street were detailed, but the main sunlit façade was left for the last, after the harbor background and sky. It needed only the slightest indication of windows and clapboards to make its white paper surface sparkle with sunlight.

The second picture was started similarly with the dark values first, beginning with the shadowed buildings at the left and the big shadows across the road, then the foliage, trunks, limbs, and branches of the trees, as shown in the half-way-stage reproduction. Then I turned to the buildings on the right, paying particular attention to the playful shadows mingled with flecks of sunlight. Before doing the sunny buildings at the end of the row, I completed the road and put in the figures silhouetted against the bright area beyond. The background houses followed, working from left to right and leaving lots of white paper in the sunniest place, with just enough indication of detail to produce brilliance. The long picket fence has no detail at all. The distance, with the little glimpse of water and the hill beyond, was done with a few light washes. The pale sky, grading to almost nothing at the bottom, was the final touch. Thus endeth the lesson!

Now, let's see - how many pictures have you painted through by yourself? If you've done the ten laid out for you in the previous lessons, and added, say eight more of your own design, that makes eighteen. Even if you are not satisfied with them, and have found yourself a bit clumsy at times in controlling the brush and color, you've made a good start and must have learned quite a lot. I'm going to give you some more arrangements to work on presently, but before you start on them I'd like to recommend that you develop the habit, if you haven't already done so, of "dry painting." That doesn't mean dry-brush work, or even working with a brush at all. It means working with your eyes and mind; and you can do this wherever you happen to be. As you regard nature from now on, begin to select picture material and arrange it mentally into designs. Look closely at the sky, at mountains, at trees, at buildings, and decide on their relative values. With what pigments could you best express their colors and textures? How would you use the brush or other tools to put the effects you see down on paper? Imagine yourself actually doing the painting, and go through the whole sequence of procedure in your thoughts. You'll be surprised at how much this will help on the next real picture you tackle. Professional painters do it all the time and profit greatly thereby.

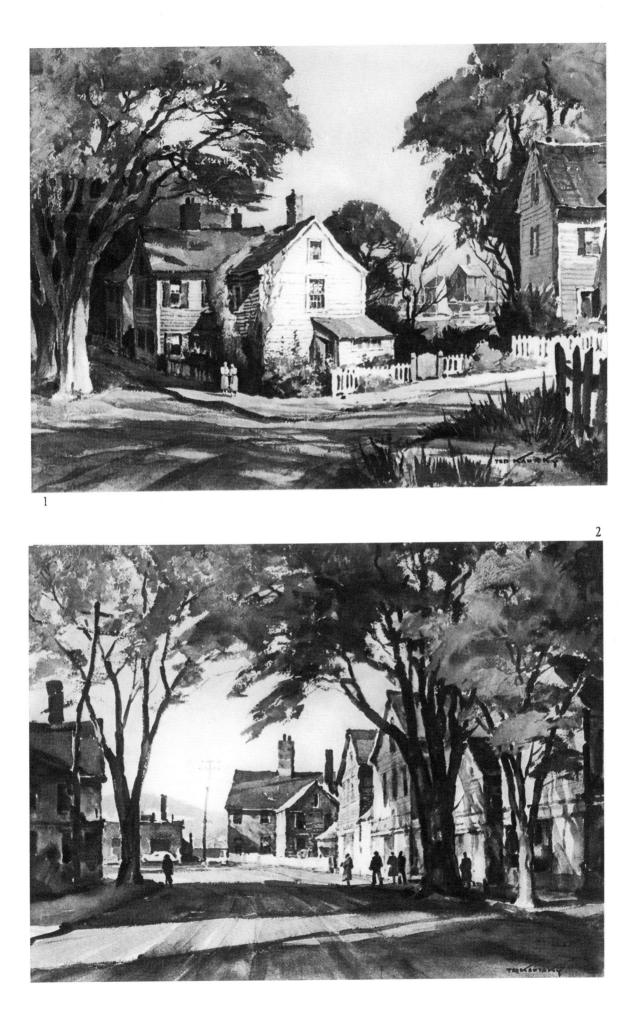

The four village scenes shown here will give you a chance to see what you can do with this type of subject. You have a certain latitude of choice, in the first one, as to the season you choose to depict, but the time of day is either early morning or late afternoon, when the shadows are long. If you choose a late spring or summer season, your palette will not necessarily require any red. But if your choice is autumn, you will need some vermilion as well as your warm yellows and browns to make the foliage seasonably colorful.

When you make your value study for the second

subject, however, you can control the mood of your final picture by your choice of time of day, kind of weather conditions, and season. It can be spring, summer, or fall; cloudy, rainy, or bright; morning or evening or midday. Please yourself about what you choose to do, but when you have made your choice, be consistent all the way through in the arrangement of shadows, range of color, and types of washes and strokes used in the painting. The last two value sketches are extras for you to do with as you wish. I know that a variety of very attractive effects can be fashioned from this material. I am counting on you to work on it thoughtfully and apply what you have learned.

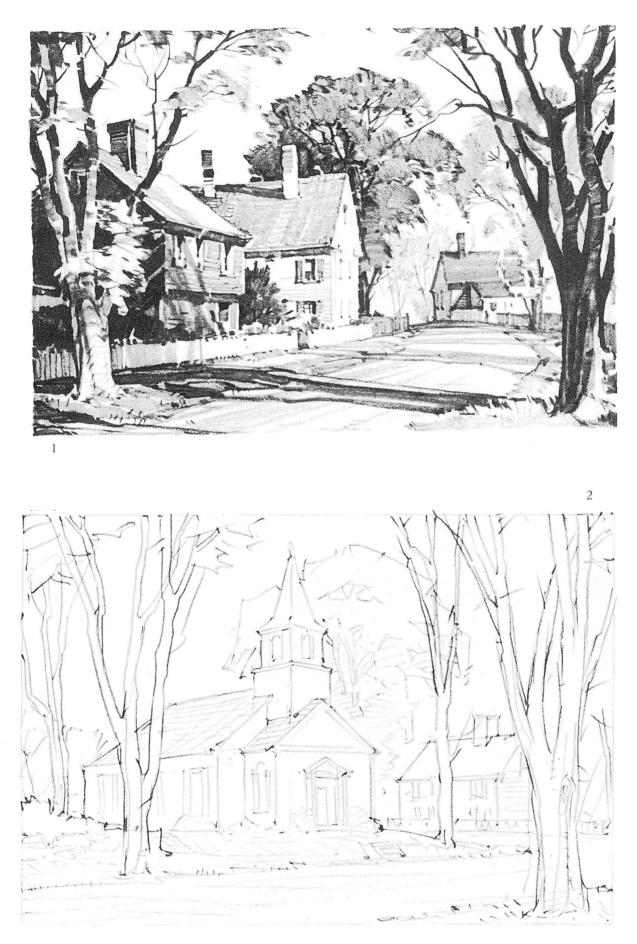

Above and facing page: Practice subjects. Heavy foliage and relatively soft values, above, indicate a somewhat hazy summer day; while sharp contrasts, used well to focus attention on the church, suggest the crispness of a sunny day in fall.

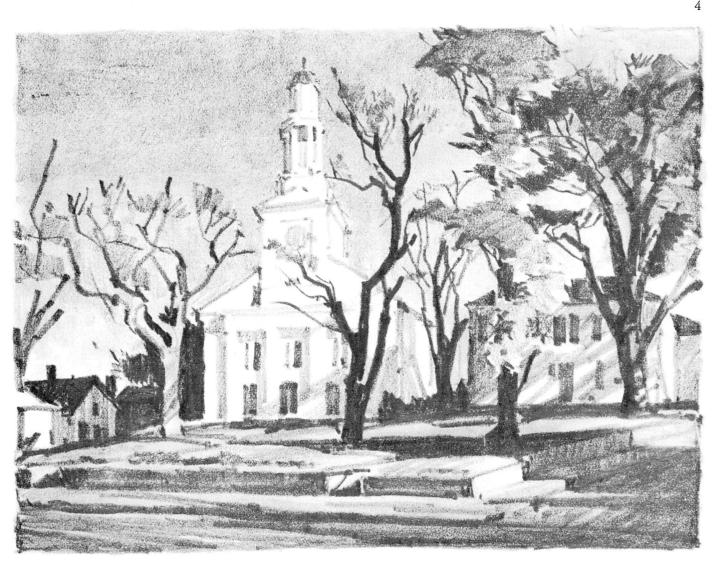

OLD WHARF

Size of original: 22" by 30". Painted on 300-pound medium rough D'Arches Palette: Ultramarine Blue, Burnt Umber, Hooker's Green Number 2, Vermilion, Davy's Gray.

Order of painting: 1. Entire dark foreground painted direct with strong color mixtures; started with roof at top left, then wall of shack, two boats, and dark piles at right. Detail in shadows modeled with knife strokes. 2. Chimney and dark gable end of center house, leaving white paper for boat silhouette. 3. Sky painted on dry surface. 4. Details of boat and wharf deck. 5. Background shacks and masts.

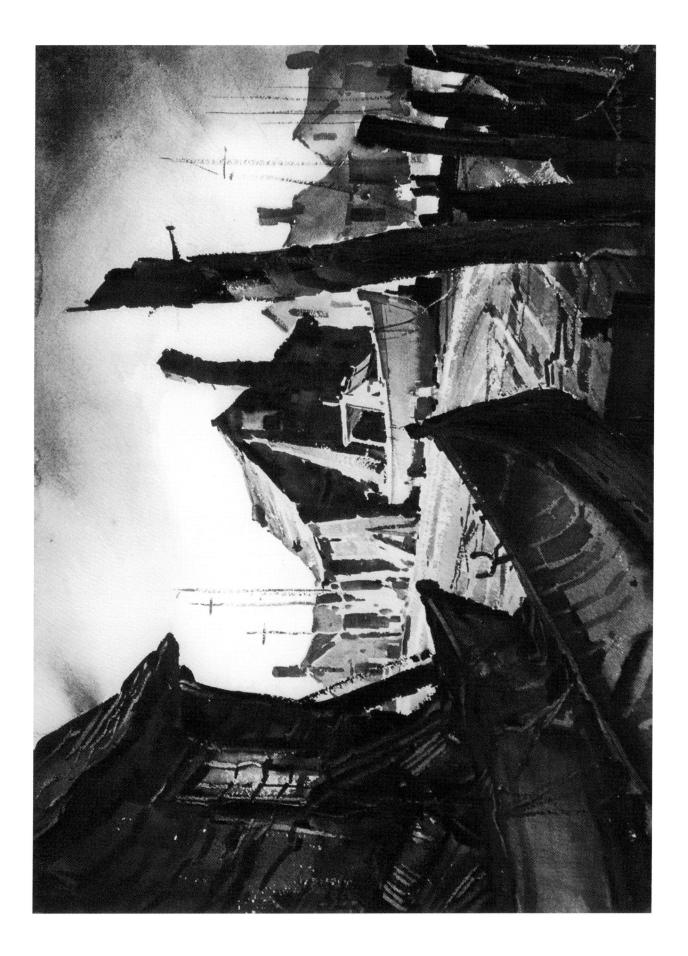

Few painters can resist the lure of a seacoast town, as is evidenced by the large percentage of waterfront subjects hung in exhibitions every year. It's not because artists as a class particularly dote upon sea food or that they find the smell of salty air especially invigorating or inspiring. The real reason, of course, lies in the wealth of ever-changing form, light, and color, in the varying atmospheric conditions which range from bright clear sun to murky fog, in the eternally busy quality of maritime life, in the miraculous play of shadows and reflections on the water, which double fantastically every effect to be seen above its surface. All these add up to an infinity of picture possibilities whether the harbor be great or small.

In a typical small fishing port we find old weatherbeaten wharves standing out of the tide on greenscummed masonry or rakish random piles. Their decks hold high a miscellany of more or less decrepit shacks and storehouses, among which spreads out a clutter of small boats pulled up for repairs, nets drying in the sun, lobster traps, freshly painted buoys, coils of rope, oars and sails to be mended, a thousand items that give interest and color to the scene. Alongside, their masts and rigging thrusting slim triangles toward the sky, rugged fishing craft restlessly rise and fall with the tides. Men move about them, stowing supplies and readying their gear for a trip to the deep waters, or, perhaps, if they have just come in, preparing to land their catch and go ashore. Overhead, the air is constantly stirred by the criss-crossing flight of soaring gulls, scanning the scene below for scraps of food. Their slender graceful wings and streamlined bodies catch the sun and form sharp animated silhouettes. When the tide is out, the shoreline glistens with wet seaweed and slimy mud, and the bare, still wet rocks are full of deep rich color. Across the water we can see other piers, with clusters of ships and boats of all descriptions tied up around them or moored away from shore. And everywhere we look, reflections-repeating the forms and colors but modifying them with sometimes weird distortions that move and seem alive. All this stirs the imagination. It is not strange that the artist reaches for his brush.

Before we take up the brush, however, we must make our preliminary pencil study, so that our picture may have design, with line pattern and values arranged to give interest and unity and balance. The first one I have prepared for you is sketched below at the left. Looking out along an old wharf, which happened to have an unusual jog in it, I saw a couple of picturesque fishermen's shacks, with sagging roofs and chimneys warped and twisted by years of exposure to the wintry gales. They were odd enough to attract attention, and I decided to

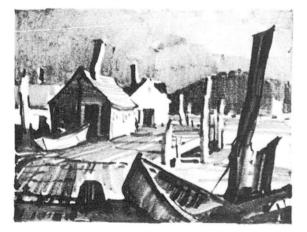

1

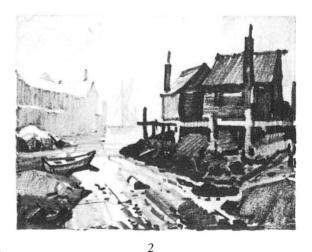

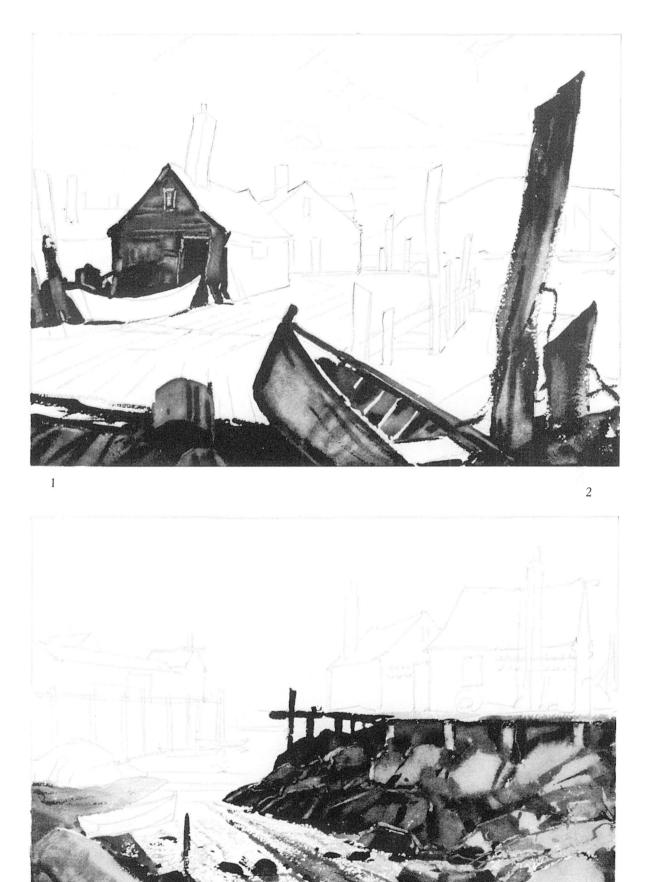

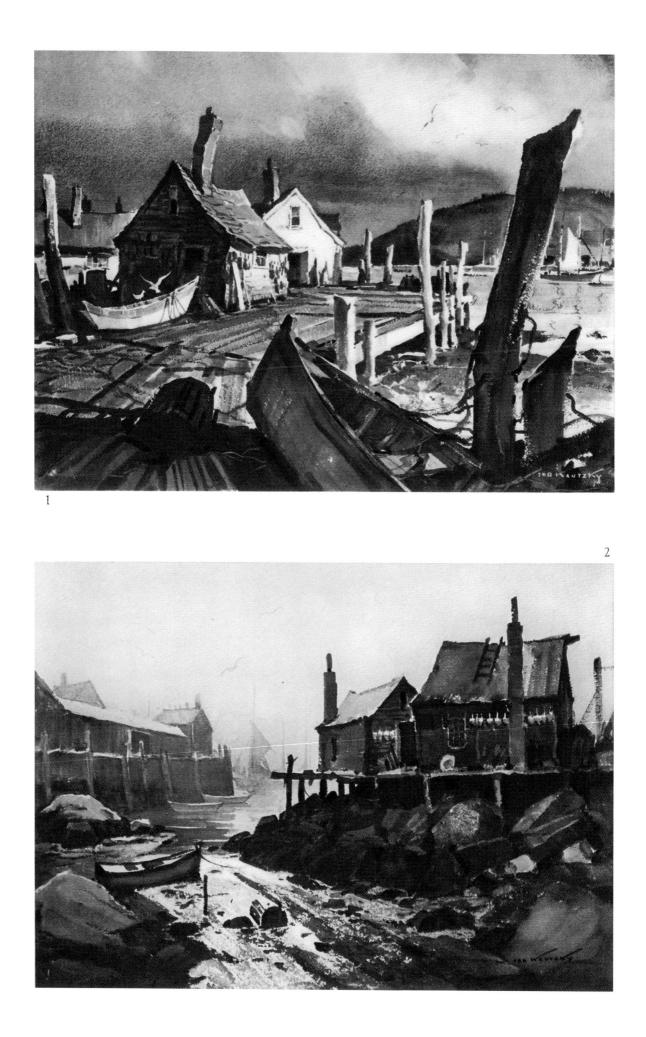

build a picture around them. I placed the further of the two a little to the left of center, so that its brightly sunlit end would be my focus of interest. The side of the other shack, colorfully festooned with lobster buoys and other fishing paraphernalia, would share in the emphasis. The lines of the wharf planking conveniently swept around in a flat, receding "S"-curve, to carry the eye properly into the central area. A hauled-up row boat in the foreground contributed several strong lines leading into the "S" and would effectively stop any reverse movement outward along the side of the wharf. The leaning foreground piles in turn would counteract the downward thrust of the piles further out and the diagonal extension of the roof slope continued along the top edge of the boat. A number of other lines were available to play their parts in the developing pattern and the values were disposed to express strong light coming from the right.

The painting proceeded with the dark values done first—the shadowed foreground, boat, piles, and the shaded end of the building. In painting the latter, I disregarded the white gulls I had planned, and I used knife strokes to model the detail. You can see in the half-finished stage where dry-brush strokes were used on the piles, ropes, etc.

The cloudy sky was painted after wetting the area, and modeled from warm light tones at the top to darker and cooler below, particularly at the left to increase the sensations of the light coming from the right. Then the background hill, the boats, and the water were put in, followed by the wharf, its supporting piles, and the wet muddy area adjacent to them. The shack in the background to the left and the sunlit side of the nearer one, plus the dory, pretty much completed the surroundings of my center of interest. Before going on to paint the focal area, however, I wanted to put in the two gulls. This I did by wetting a sufficiently large space around them, wiping the color out with a cloth, and using artgum to reduce it to white. The gulls were carefully sketched in and the dark area repainted to give clean silhouettes. A few final touches on the bright façade of the fish house completed the picture.

I find that a palette of few colors works very well on subjects of this kind. French blue, burnt umber and Hooker's green number 2 will take care of most needs, with perhaps just a touch of red for local color here and there. When it is foggy, cool and

warm grays may be used in the misty parts, with the over-all scheme painted in a greenish tint, or a purplish tint, or just gray. Turning back now to the second picture of this lesson, I have taken a view at low tide, looking out between two wharves. The wharf at the right sits precariously high on a projecting point of rocks, while its contrasting neighbor is solidly based on heavy masonry. The foreground area is occupied by the slimy wet-mud bottom, strewn with dejected flotsam left by the ebbing tide-an unpleasant sight were it not kissed into sparkling radiance by the light from above, which reflects from its shiny surface. This band of brilliance leads our eye leftward to the water's edge, where our attention is swung abruptly to the right by the sharp silhouette of the dark point of rocks against the luminous mist beyond. In the opening between the two piers we see faintly in the fog a small fishing vessel, just returned to its moorings, its sails still partly rigged. This will be our center of interest, caught and held by the pointing masses on either side and reached by the powerful zig-zag of light receding from our point of view.

In addition to the green, blue, and umber mentioned above, my palette for this picture included Payne's gray and vermilion. I painted first the rocky point at the right and the base of the wharf, using very dark values toward the end and working back toward the shore with lighter tones, the gradation calculated to give depth. Then I did the wet harbor bottom with dry-brush strokes, giving them enough direction to emphasize the perspective. The rocks and shadows at the left were next, followed by the stranded boat. In doing the two lobster shacks at the right I made the outlines clear and the details less distinct. The other wharf was made to recede, with softer edges and paler washes as it retreated into the fog. The more distant rock, the water reflections, and the two small boats were also given atmospheric perspective. Finally, the background sailboat, the sky, and the seagulls were painted with extremely light values to indicate mist and distance. Now, it's time to go home to supper! Naturally, we'll have lobster!

On page 91, there are two picture arrangements on which you are going to work. They deserve quite a lot of study. But I think you are going to have fun getting acquainted with the details of the harbor shoreline, and I predict that you will want to paint more of it next summer.

If you share my enthusiasm for boats and the sea, you will like the pictures I have given you here to turn into large watercolors. Number 1 will provide a chance to experiment with getting misty effects, in which the detail is indistinct and everything becomes fainter and loses itself in the fog as it goes into the distance. I have told you how to do this and now you will try it for yourself. See if you can make it so that you can almost smell the damp salty air as you look at the picture!

The second subject may be done more brightly, if you like, with lots of sunshine and blue sky to result in a rich play of sparkling color. The boats and their reflections give you the opportunity to study the relationships of value and color which I have discussed in previous chapters. Remember that, in general, when lighter surfaces in the foreground are sunlit, their reflections will be darker and will take some of their color from the local color of the objects concerned; but if the boats' hulls are dark, the reflections will be the color of the water as you look down into it, and their values lighter. You will find lots of places here for the use of dry-brush strokes, for the shimmer of distant water in sunlight, the glint of brilliant light touching the edges of piles, the delicate lines of rigging seen against the sky, etc. So go ahead and practice, and paint well on your next seacoast trip.

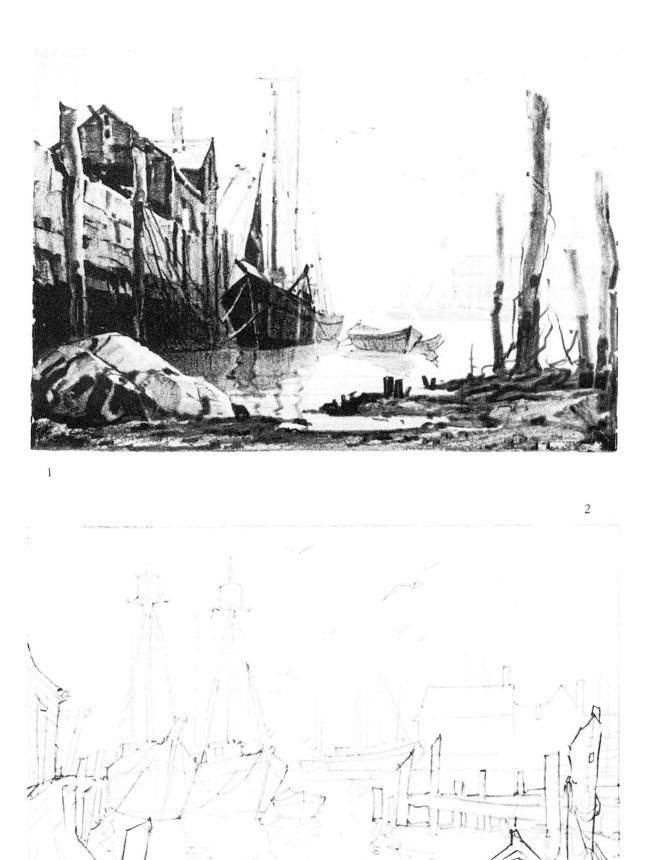

ALONG THE BEACH

In summer, people from inland flock to the ocean shore where they can enjoy the sunny outdoor life and the many forms of recreation afforded by the sea. They thus become familiar with another type of landscape—one involving large expanses of open water, sky, sand, and rocks, but comparatively little vegetation. Those among them who can paint a little are tempted by the beauty they see around them, but sometimes baffled by the absence of the familiar trees and houses of their home environment. They find it a bit difficult at first to make an interesting picture out of the few elements at hand. Ingenuity is necessary to convey a sense of the vast horizontal spaciousness without permitting monotony to dull the observer's pleasure.

In making a beach scene, we must combine a feeling of great depth with enough contrast and interest in our foreground and middleground to give us pattern and design. It is best not to look directly out to sea, but rather more or less along the shore, so that we can emphasize the perspective with something tangible, making use of all the rather sparse details that are ordinarily available. We have the receding shore line itself, with its fringe of breaking waves; the pools of water and undulating creeks crossing the sand; half buried rocks and ledges raising their massive sculptural forms out of the water; garlands of seaweed and scraps of driftwood and debris cast up by the tides. To add life, we can introduce occasional boats, figures, seagulls, water reflections, passing cloud shadows, etc. We can, if we wish, place our horizon low and make our interest mainly in the sky if it has formations of clouds. More often, perhaps, we will choose a high horizon, with attention centered on the features of the beach. It is usually best not to have the horizon running through the middle; the monotony of even spaces is difficult to overcome.

The sand will occupy a large part of the picture area, with a much narrower strip for the distant sea. The painting of the sand itself is therefore important. When it is dry, it is a very light warm color; when wet, it is darker. Since the part between the tide levels is alternately wet and dry, we usually find a gradation in value here-darkest at the water's edge, lighter on the landward side. When the sun shines on the sand, it reflects a warm light onto the shaded sides of any adjacent objects, which must be taken into account in painting them. Where the white surf breaks upon the beach, we will leave white paper for the long stripes of foam. At low tide, some flat parts of the beach will be wet and glistening and will reflect the distant sky as well as things next to them. The tidal currents mould the beach as they pass over it, so that when the water has receded there are long sweeping curves delicately channeled in the smoothly packed surface in some places, while in others the sand is left rippled into thousands of little ridges which catch the low slanting sunlight in interesting tex-

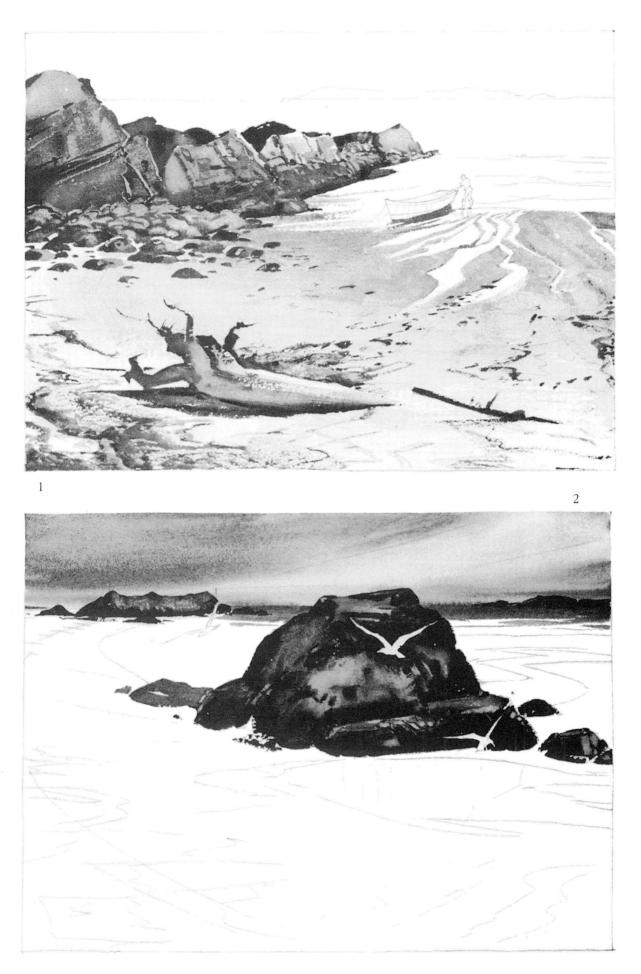

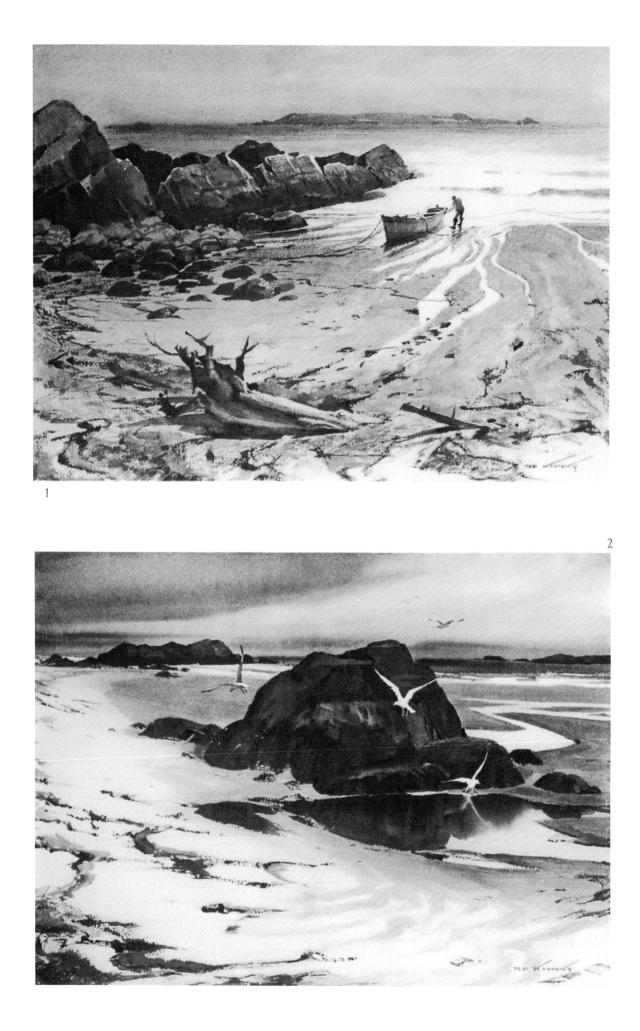

tures. All these things are observable and can be used in building up your pictures. You will need to note them well, for it will be rare to find compositions ready made and you will want to introduce these natural effects where they will fit into your designs.

In the first of our two examples, my eye had been caught by a grouping of little streamlets converging at the water's edge and making an interestingly irregular pattern. At the left was a group of rocks, thrusting darkly into the smooth shallow water and partly enclosing a small triangular area, just off center, where the sky was brightly mirrored. The convergent lines and the intense light made that spot ideal for a center of interest. To provide the interest, I introduced a small boat with a fisherman beside it digging for clams. These silhouetted sharply against the bright water and made an admirable focusing point.

I had chosen a high horizon, so that the sky and the sea would occupy a smaller part of my picture and the foreground beach would dominate it. Some foreground detail would be needed to relieve the emptiness of the beach and to produce a counter movement leading the eye in a swinging curve to the left and out along the rocks to the boat. I looked around and found an old tree root that had been washed ashore and sketched it in where it would help my purpose. Some odds and ends of driftwood and seaweed were carefully disposed to complete the movement and, at the same time, soften the attention power of the picturesque root, which might otherwise compete with the boat. In the sea beyond was an island, which I moved somewhat to the right to close the escape route on that side and define the horizon. And there was my picture! But I had to make it; it was not there to begin with.

In painting it, I did the rocks first as powerfully as possible for the darkest note in the picture and to emphasize their solidity. Then beginning very carefully with the darker sand at the water's edge, I painted in the beach, leaving white paper for the rivulets and using more dry-brush strokes as I worked into the lighter foreground sand. The old tree root and the scattered seaweed were then put in and the picture had arrived at the stage shown on page 93. Now I could paint the sky and distant water in their proper relative values, along with the offshore island, and finally the details of the point of interest-the boat, the figure, and the greenish waves.

In the second picture, the horizon was again high, and I chose to make my center of interest a big dark rock in the foreground, with its reflection in an adjacent pool of water. To give it greater liveliness, I put in some carefully studied gulls, silhouetted in graceful flight positions against the rock. The sweeping curve of the beach vanished powerfully into the distance and was countered by the cloud lines swinging down to meet them. A tidal creek on the right of the rock formed a flat S-curve leading in from that side. Note that the top of the large rock projects above the horizon, thereby receiving greater emphasis. In general it is well to avoid letting the top of any important feature exactly touch the horizon: it should be either above or below.

My palette for this picture included only French blue, burnt umber, and Hooker's green number 2. The sky was painted wet and the narrow strip of sea was put in while the surface was still a little damp, so that it would blend into a soft edge at the horizon. Then the foreground rocks were done with heavy dark color, carefully worked around the outlines of the white gulls. The distant rocks were made slightly lighter. In doing the sandy beach, I made the wet sand darker than the strip above the last tide mark, and left white paper for the winding creek. The foreground sand was also largely white paper. This brought me to the puddle; its reflections were deliberately made with soft edges to make the water seem wetter. The seaweed, which appears so casual, was in reality carefully designed, its color dark and warm in the foreground and cooler and lighter farther away, and its undulations diminishing successively towards the distance. The last touch was a slight tint of wash over the tidal creek and puddle, so that the foreground sand would be sunnier.

We are now almost at the end of this course of study, and I want to take this opportunity to wish you the best of success in your further adventures in watercolor painting. After all, it is only what you do from now on that counts; I have been able only to give you some pointers to help you over the early stages of your career. I hope also that I have aroused your enthusiasm to go further. If a goodly number of you should develop into successful painters, I will feel sufficiently rewarded for my work.

You can see here out of what slight material a passably good beach picture can be made; just a few rocks, a bit of sand, some water, and the distant sky. The first example upon which you may try your skill at enlarging and painting has a simple basic scheme. A small curving inlet from the sea forms a wide sweeping "S," lying flat on the receding plane of the beach. Across the waist of the "S," a straight diagonal dark band of rocky formation slopes downward from right to left. Where these two dominant lines intersect there is bound to be a strong area of interest, occupied in this case by the two rocks facing each other across the stream. It is a different arrangement from any we have so far encountered. But you now know enough to paint it.

The second picture will be your last practice subject on a specific lesson. Think well, as you make your pencil study for values, about how the lighting should fall for best results. I have suggested lightly that the sand will be wet in some places and dry in others. You know what this means. You also know how to handle reflections and skies and distant water and rocks. So go ahead. That's all there is to it! Just have courage, and keep on working.

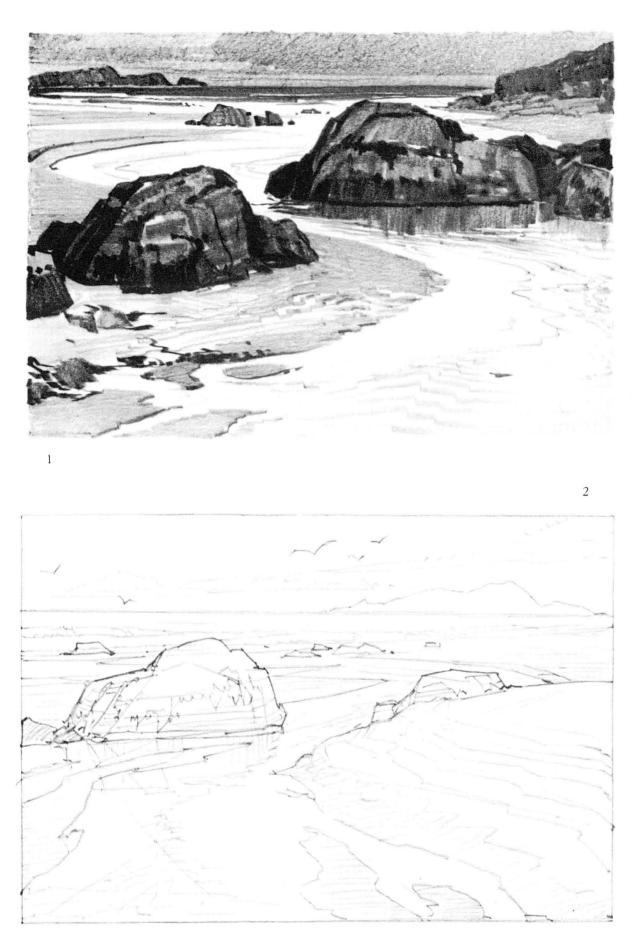

ROCKS AND REFLECTIONS

Baltimore Water Color Club, Popular Prize, 1949.

Size of original: 22" by 30". Painted on 300-pound medium rough D'Arches. *Order of painting:* 1. Sky area wet and painted lightly on wet surface. 2. Large rocky island painted, leaving white paper for smaller rockpile in front of it to be painted separately later. 3. Water and foreground surf. 4. Dark puddles with reflection. 5. Far background rocks. 6. Middleground rocks with light touching top edges of central group. 7. Sandy beach. 8. Seaweed and gulls; foreground gull left white with dark rock painted around silhouette.

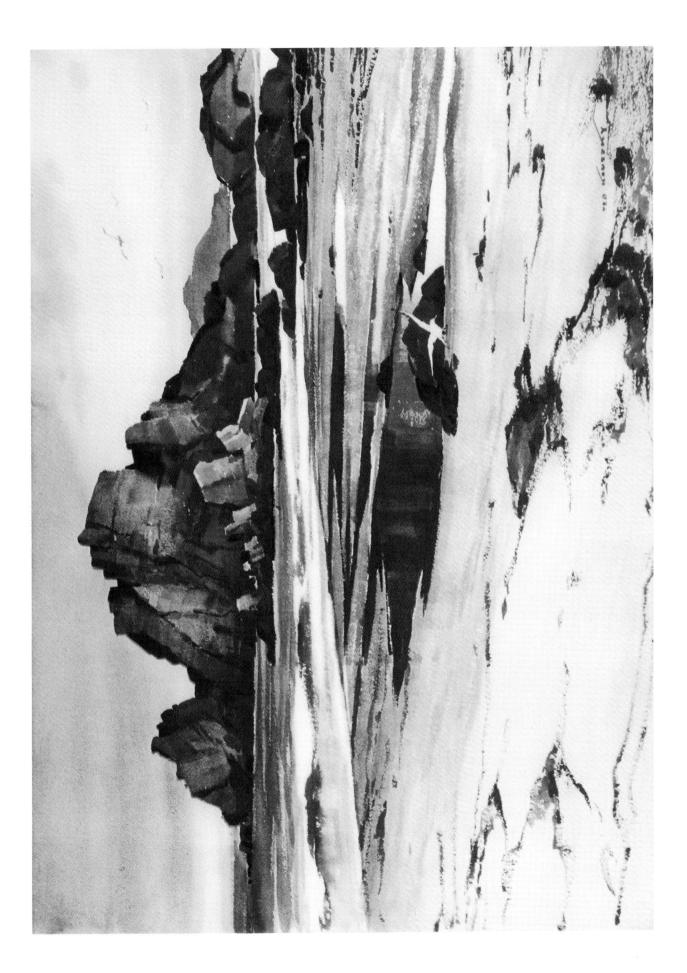

MORE PRACTICE

At most schools it is traditional to test the student's knowledge at the end of a course. Here, you are asked to test yourself—to discover your own strengths, and weaknesses, to find out how well you have learned your lessons. Then you are given opportunity to overcome your weaknesses and to solidify your strengths, through review and practice.

1. Start out by simply leafing through the illustrations; don't bother to read the captions at this time.

2. Then leaf through again, stopping to analyze pictures that seem familiar. You will find a number of these, both in black and white and in color. They will look familiar because they are composed of subject matter that has been used in the book before -from a different viewpoint, at a different time of day, a different season of the year, or, perhaps, just a different mood. The sketch at the bottom of the facing page, for instance, will probably prick your memory. It is one of many studies made for the painting reproduced on page 26. And the sketches on page 120 should certainly recall one of the subjects on page 71. On page 132 there is a picture seen from a different viewpoint but the subject is the same as that in the practice sketch on page 97. Try comparing your treatment with this one. One note of reassurance. Don't be unduly alarmed, if, when using the same palette, your color results are slightly different from the reproduction in the book. You are comparing your result with a reproduction, not with the original painting itself. Because the process of reproduction is largely a mechanical procedure with definite limitations, it is almost impossible to achieve a reproduction that is an exact replica of the original. You may even detect colors not included in the palette or possible to get through mixtures of palette colors. But don't use this as an excuse, in over-all effect your painting should closely resemble the reproduction.

3. Now leaf through once more, stopping at illustrations that seem less familiar (and probably more challenging) and try analyzing them. If you have been able to paint these pictures mentally, with a reasonable degree of assurance, start testing yourself on paper. Pick a group of 5 or 6 pictures, those that appeal to you most, and try doing versions of your own.

If you start with a color reproduction, try duplicating it without reference to text or caption. If you want to change the composition a bit, or the mood, don't forget your preliminary value sketch. When finished, check your palette and procedure with the caption and related text. Or, if you start with a black-and-white illustration, try doing a color version.

But don't copy for the sake of copying. Copy to improve your technique and to underline what you have learned, or not learned, so far. Remember that you are testing yourself. Think as you work and keep asking yourself questions.

Why does this road curve as it does and what would happen if its direction was changed?

Was this sky done on wet or dry paper? With a single wash or with superimposed washes?

Why are the puddles on this road shaped as they are?

Was this tree modeled with a brush? With a rag? With a pocket knife? And why?

Why is this water reflection dark and that one light?

Why is one object reflected in the water while another is not?

Why is there a rather bright spot of color under the roof of a porch in shadow?

If you have practiced enough, if you have reviewed text whenever necessary, if you have analyzed all pictures in this section, while giving a confident answer to every question you could think of, then the book has served its purpose. You are now ready to work independently.

Once on your own, keep an open mind, absorbing knowledge wherever you look. Keep an objective, analytical attitude toward the work of others—but mostly, at this stage, toward your own. And paint, *paint*, PAINT; only in this way will your talent develop to its fullest potential.

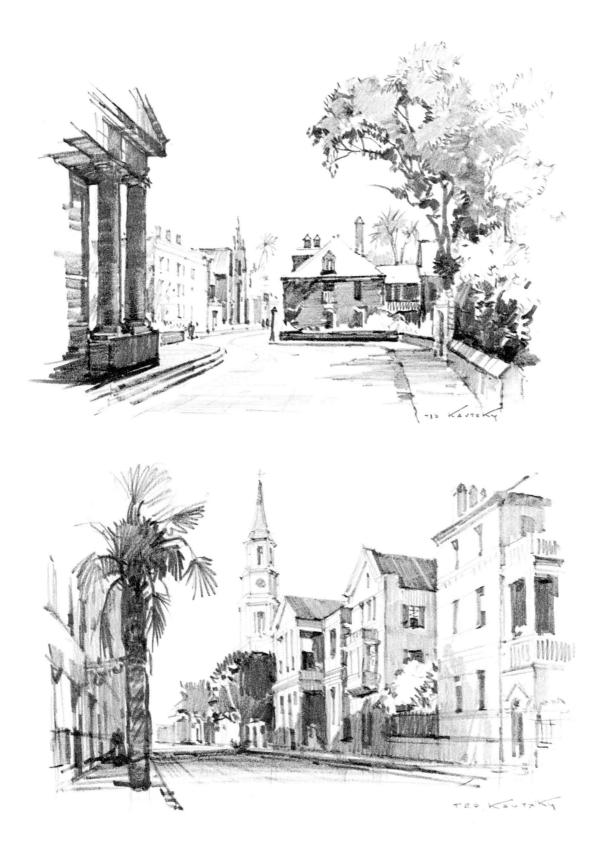

CHARLESTON, S. C.

Size of original: 22" by 25". Painted on 300-pound D'Arches, medium-rough surface.

Palette: Cobalt Blue, French Ultramarine Blue, Raw Sienna, Burnt Umber, Alizarin Crimson, Hooker's Green Number 2, Cadmium Yellow.

Order of painting: 1. The Live Oak in the right foreground, beginning with the general shapes of the shadowed foliage and using a square-end brush. The main branches, limbs and trunk were struck in next, using dark values for the shadowed areas and medium to light values in the sunlit portions. 2. Modeling of foliage and Spanish moss was finished, using dry-brush strokes in vertical sweeps for the moss. 3. The cast foreground shadows up to the road's edge. 4. The middle and background trees, the sunlit areas of grass and the shrubs in front of the house. 5. The roof and shadow areas of the house. 6. The road and the continuation of the cast shadows across it. 7. The sky. 8. The final details in the sunlit areas.

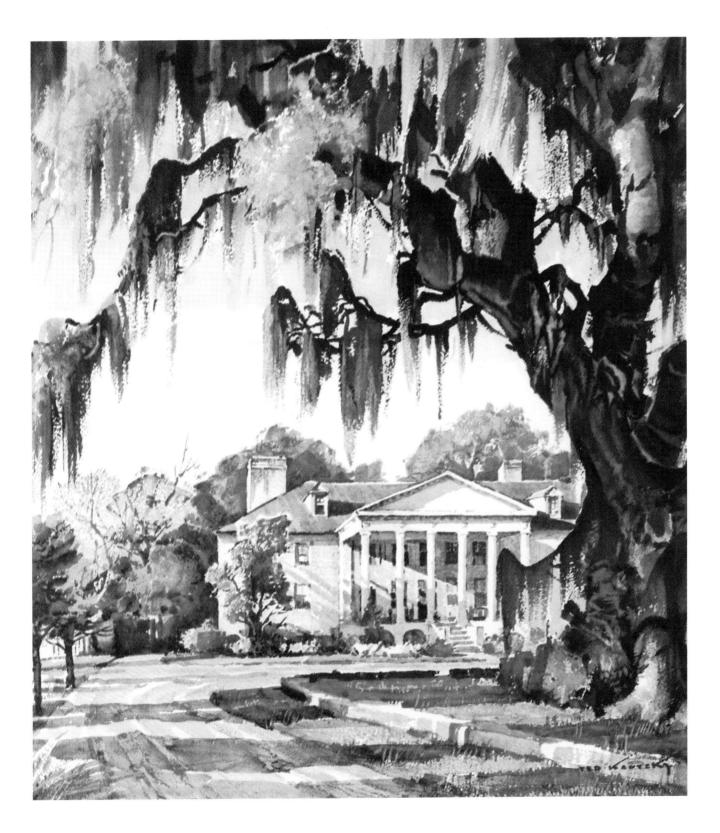

Above and facing page: Studies in composition and value for Rural Pennsylvania, page 106.

n

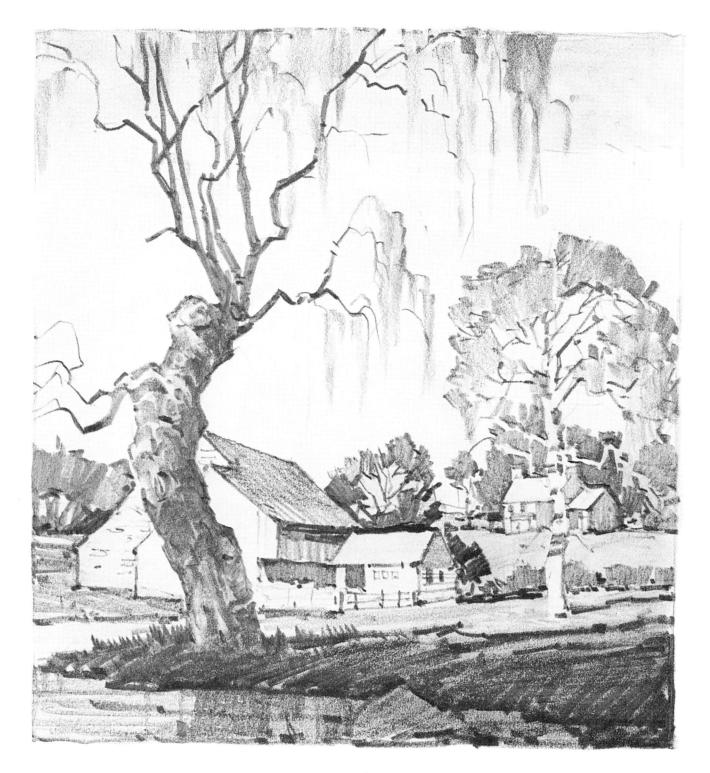

Size of original: 22" by 25". Painted on 300-pound D'Arches, medium-rough surface.

Palette: Cobalt Blue, French Ultramarine Blue, Raw Sienna, Burnt Umber, Aureolin Yellow, Hooker's Green Number 2, Cadmium Orange.

Order of painting: 1. Sky pattern and background hills, leaving white paper for light areas of the sycamore tree and for the tree foliage behind the barn. 2. Shadow side of barn, and shadows cast by barn tree and fence. Notice the warm reflected light in the barn's shaded areas. 3. Middleground fields, including hedgerow and tree behind barn. 4. Plowed fields on right and left. 5. Front of barn including barnyard. 6. The sycamore tree, the barn roof, the background buildings and the roadside grasses. 7. The road, using dry-brush strokes to indicate the graveled surface. Brush moved in the same direction as the road and values graded from dark in the foreground to light at the bend of the road.

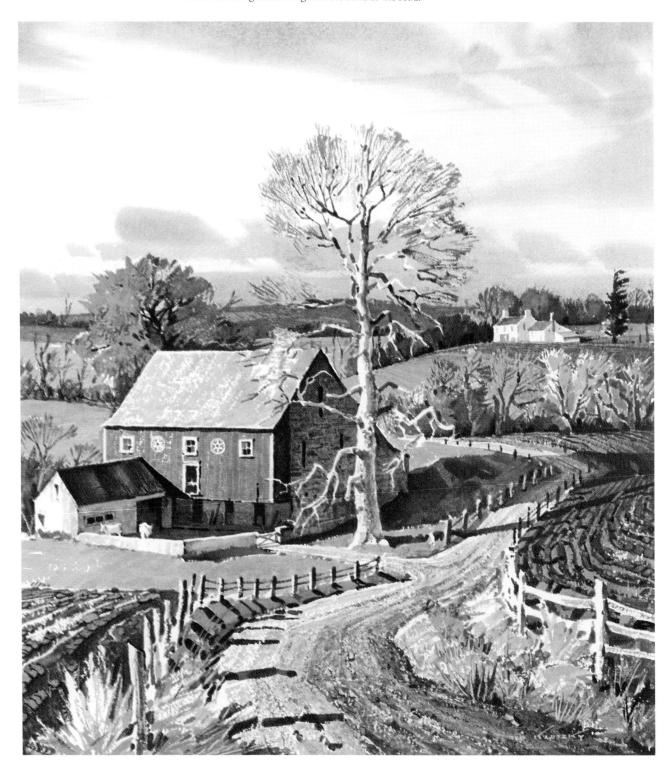

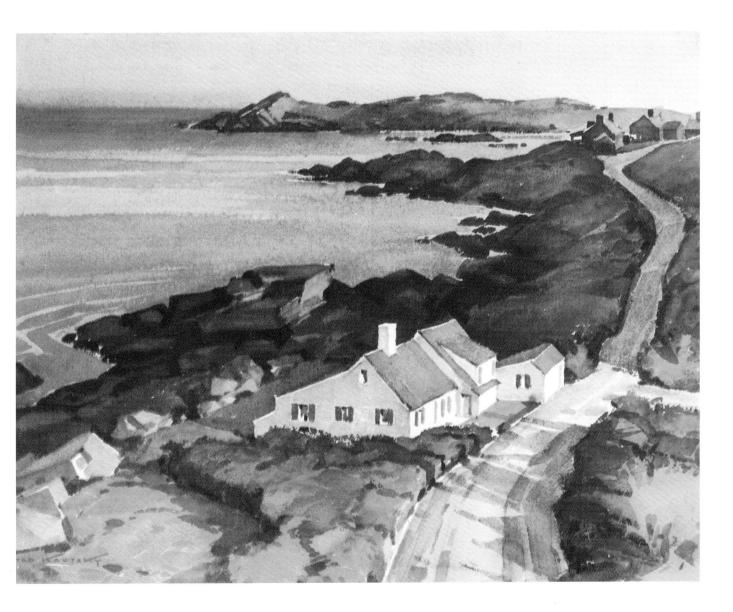

SHORELINE AT CAPE ANN

Size of original: 22" by 30". Painted on 300-pound Whatman paper, medium-rough surface.

Palette: French Ultramarine Blue, Antwerp Blue, Burnt Sienna, Raw Sienna, Lemon Yellow, Hooker's Green Number 2.

Order of painting: 1. Sky. 2. Rocky shoreline, leaving the sunlit surfaces white paper. 3. Shaded middleground on both sides of the road, and dark foreground areas. 4. Background houses and shaded end of the road. 5. Background promontory. 6. The sea. 7. The foreground and the sunlit sides of the rocks. 8. The foreground house, working from dark to light.

NORTHEASTER ON CAPE ANN

North Shore Arts Association, Publicover Memorial Prize, 1947.

Size of original: 22" by 30". Painted on mounted Whatman, rough surface. *Palette:* Vermilion, Burnt Umber, French Blue, Hooker's Green Number 2, Raw Sienna, Payne's Gray.

Order of painting: 1. Dark foreground rocks and extending shoreline below road. 2. Sky and hillside area above road, sponged in and painted while wet. Payne's Gray with a little Burnt Umber and French Blue used for sky; Hooker's Green, Payne's Gray, and a little Burnt Umber for hillside area. 3. The water. Green, sienna, and gray used for darker unbroken surface; surf left white paper toward center, with light gray tint over left foreground and background spray and spume. 4. The house; painted simply, with detail suppressed. Note use of drybursh strokes along breaking waves and silhouette of foreground rocks.

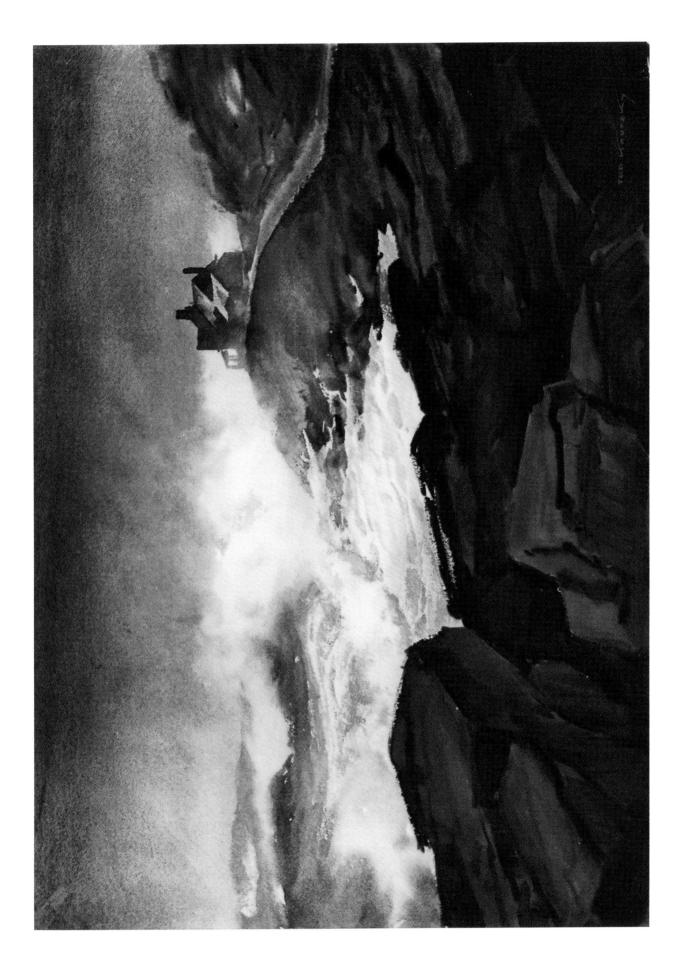

Bear Lake, Colorado

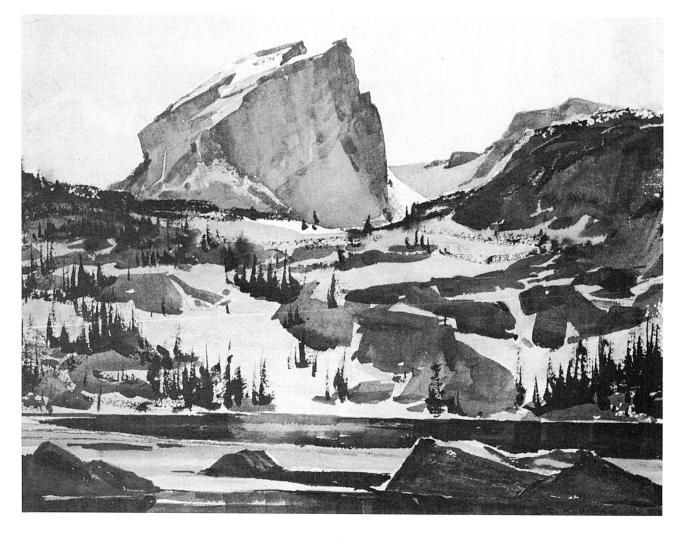

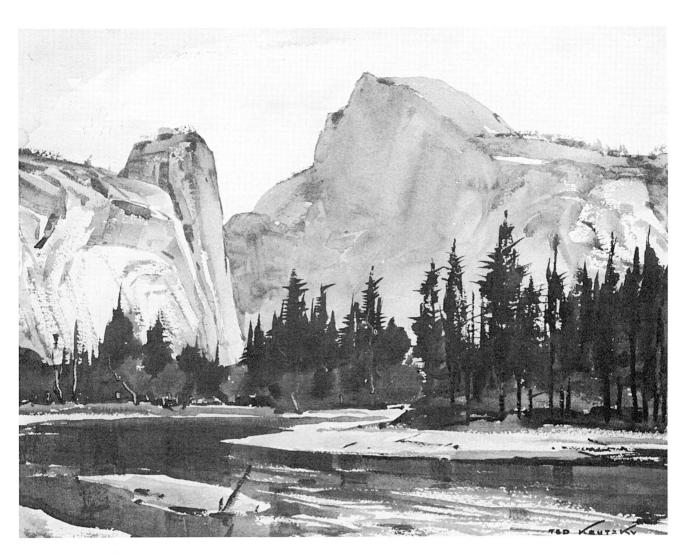

Half Dome, Yosemite Valley, California

SCHOONER IN HARBOR

American Water Color Society, Obrig Prize, 1949.

Size of original: 22" by 30". Painted on 300-pound rough D'Arches. Palette: French Ultramarine Blue, Burnt Umber, Hooker's Green Number 2, Winsor Blue.

Order of painting: 1. Wharf at left, dark foreground rocks, and shaded side of wharf at right. These dark values set scale for rest of picture. Both dry-brush strokes and knife strokes used for rocks and piles. 2. The water surface: horizontal dry-brush strokes for shimmer of sun in distance, continuous wash in foreground, occasional white paper around rocks. Note direction of brushwork in wash. 3. Schooner, with masts, sail, and rigging. 4. Reflections of schooner, masts, sail and wharves; these are superimposed on water. 5. The hilly promontory and the sky, which was treated simply with few strokes and left mostly white paper. Sunny effect of this picture largely produced by careful disposition of white paper areas.

Size of original: 22" by 25". Painted on 300-pound D'Arches, medium-rough surface.

Palette: Cobalt Blue, Ultramarine Blue, Burnt Sienna, Raw Sienna, Vermilion, Hooker's Green Number 2.

Order of painting: 1. Dark trees on left, dark areas in left foreground extending over to shadowed areas of rocks. Patches of white were left for highlighted water areas and water reflections. 2. Dark trees on right. 3. Middleground trees. 4. Sky pattern. 5. Water, except reflections. 6. Final modeling in highlight areas. 7. Water reflections and fisherman. The fishing pole and line were lifted out with a razor blade.

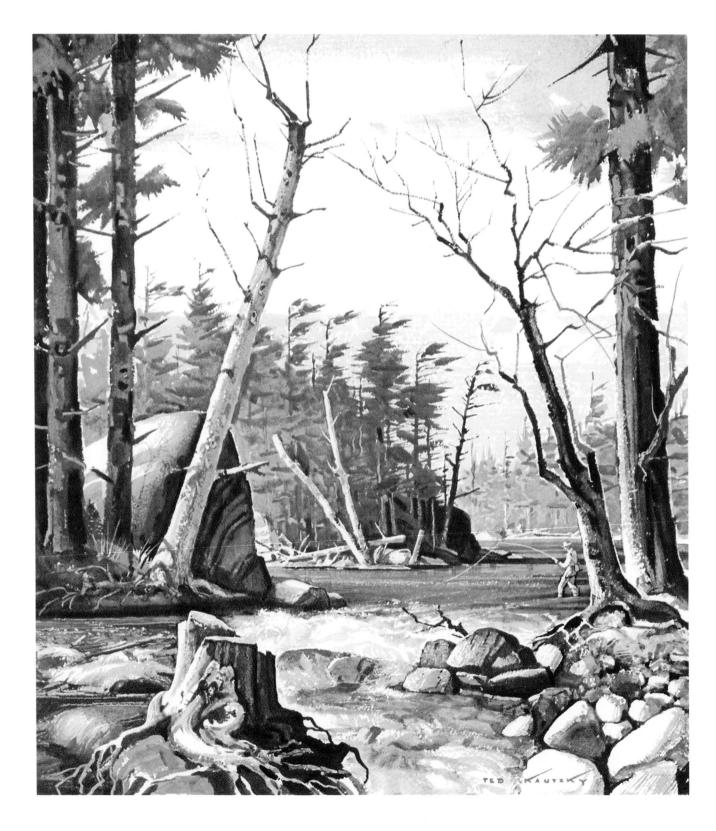

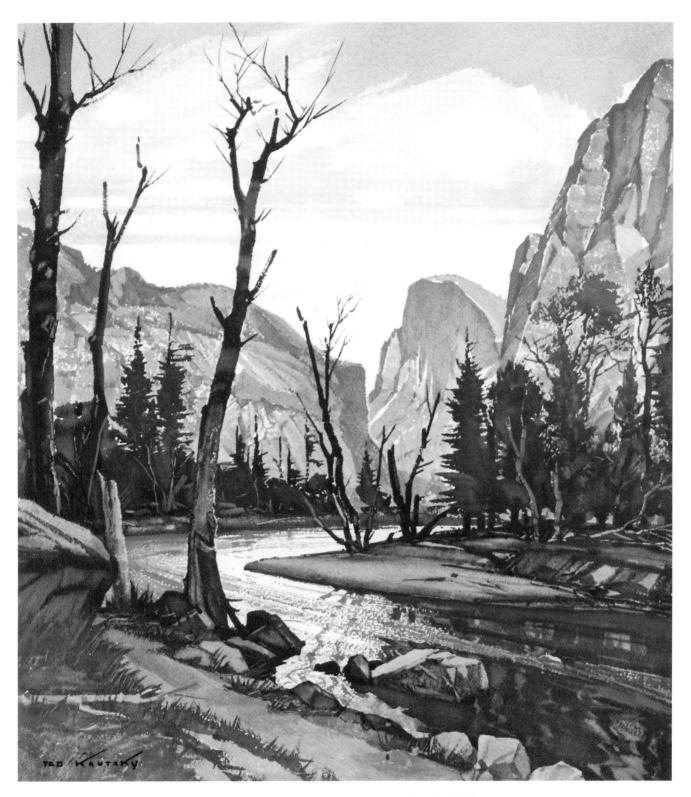

YOSEMITE NATIONAL PARK

Size of original: 22" by 25". Painted on 300-pound D'Arches, medium-rough surface.

Palette: French Ultramarine Blue, Burnt Umber, Raw Sienna, Hooker's Green Number 2, Alizarin Crimson.

Order of painting: 1. Sky. 2. Dark trees at left. 3. Background rocky hills. Note how brush-stroke direction is used to define planes. 4. Middleground trees. 5. Water reflections. 6. Shorelines. 7. Dry-brush strokes on highlighted water areas to indicate movement and direction.

Arrangement and value study of California's giant sequoias. This sketch is uncomplicated in subject; nevertheless, it will challenge your ability to interpret texture, mood and perspective. Fishing Boats

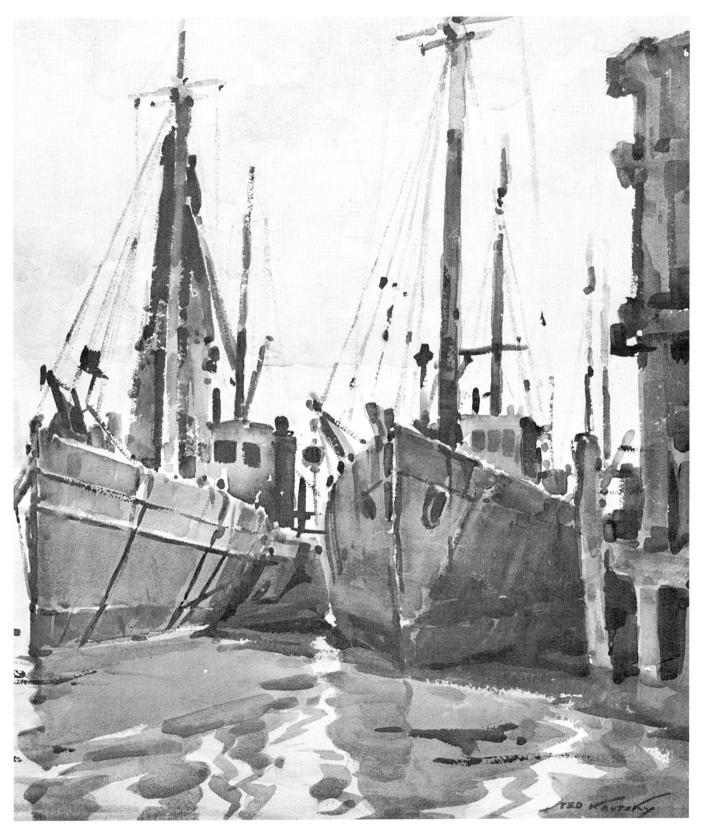

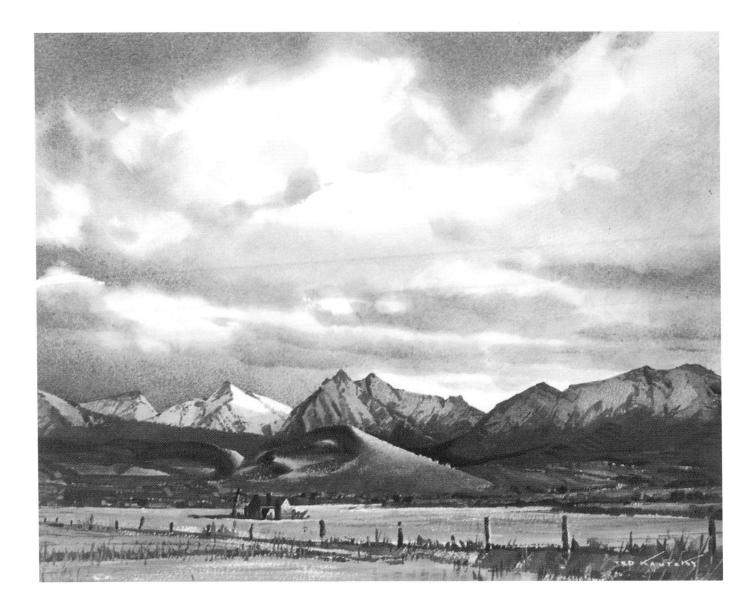

SNOW PEAKS, COLORADO

Size of original: 22" by 30". Painted on medium-rough Whatman paper. Palette: Antwerp Blue, French Ultramarine Blue, Hooker's Green Number 2, Burnt Umber, Raw Sienna, Burnt Sienna.

Order of painting: 1. The sky, using rich juicy washes on a wet surface. 2. The mountains, grading them in value and directing brush strokes to indicate the sharp variations in planes. 3. The dark areas of the grassy hills. The modeling here emphasizes the soft roundness of the hills, which contrasts well with the craggy peaks in the background. Dry-brush strokes were used on the hills and on the foreground flatland to indicate shimmer. 4. The dark grasses in the foreground and the fence. 5. The building.

COLORADO FOOTHILLS

Size of original: 22" by 30". Painted on mounted Whatman, rough surface. *Palette:* Burnt Sienna, Raw Sienna, Raw Umber, French Ultramarine Blue, Cobalt Blue, Hooker's Green Number 2.

Order of painting: 1. The sky, washed in on wet paper. 2. Dark values of background hills, painted while surface still slightly damp. 3. Dark trees at right and middleground. 4. The two trees at left; these tie foreground and background together. The modeling of the trunks was done with a knife. 5. Other foreground trees and rocks. 6. Final modeling of snowy hills, middleground, and foreground snow. 7. The buildings.

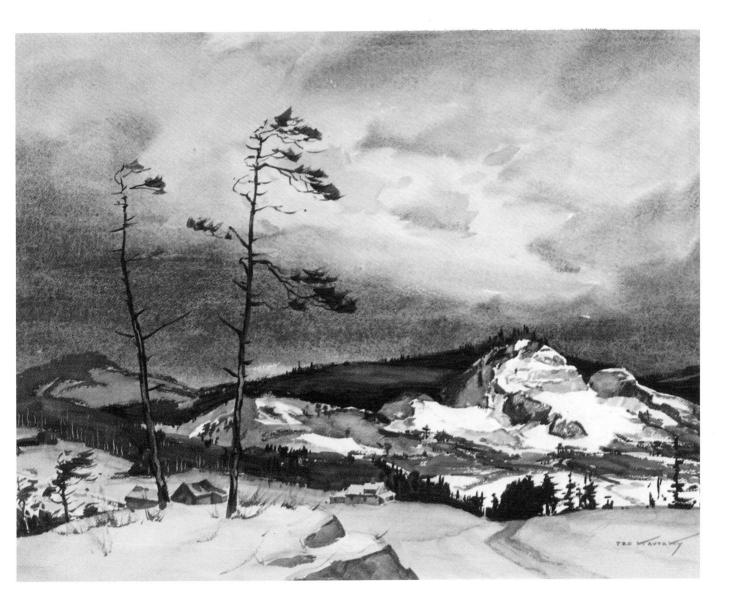

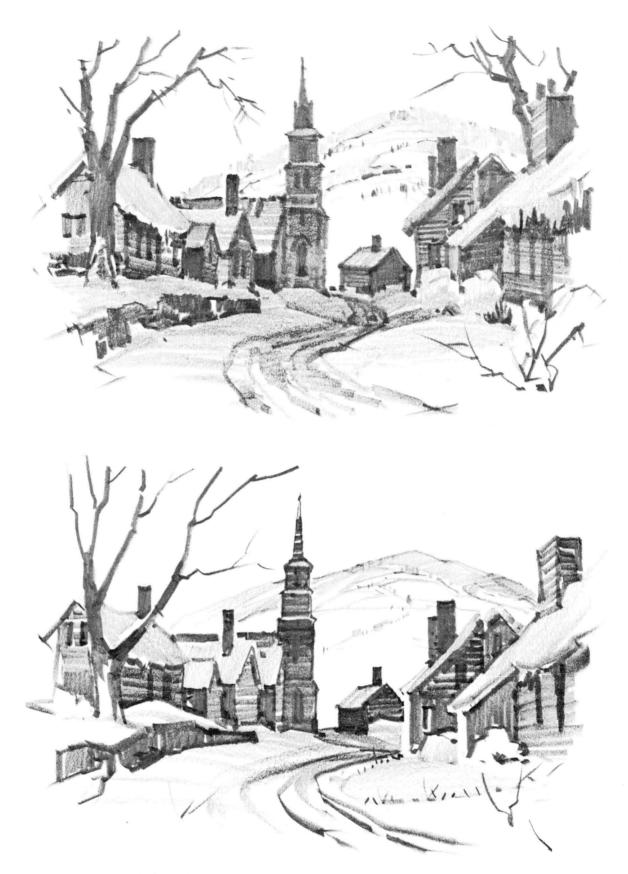

Backlighted studies made from the same viewpoint as the top painting on page 70.

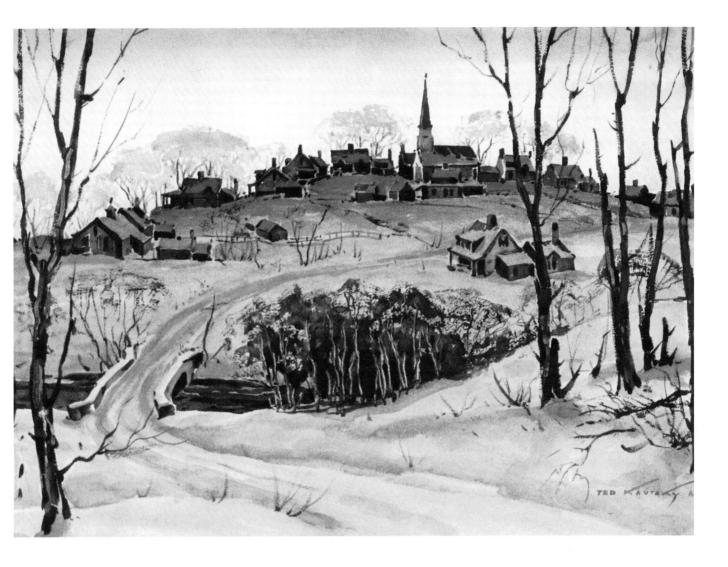

NEW ENGLAND IN WINTER

Size of original: 22" by 30". Painted on 300-pound D'Arches, medium-rough surface.

Palette: French Ultramarine Blue, Antwerp Blue, Burnt Umber, Raw Sienna, Burnt Sienna, Hooker's Green Number 2.

Order of painting: 1. Sky, done on wet paper and graded from dark to light. 2. Background trees, done while paper still slightly damp. 3. Dark sides of houses. 4. Foreground and middleground trees. Note use of dry-brush strokes. Tree trunks in middleground clump were wiped out with a knife. 5. Dark stream of water and dark accents on bridge. 6. Shadowed snow, working from dark at the top to light at the bottom, and modeling of the top of the church steeple. 7. Light areas of bridge, middleground house and church steeple. 8. Final modeling of snowy hillside and road.

Fall in Vermont

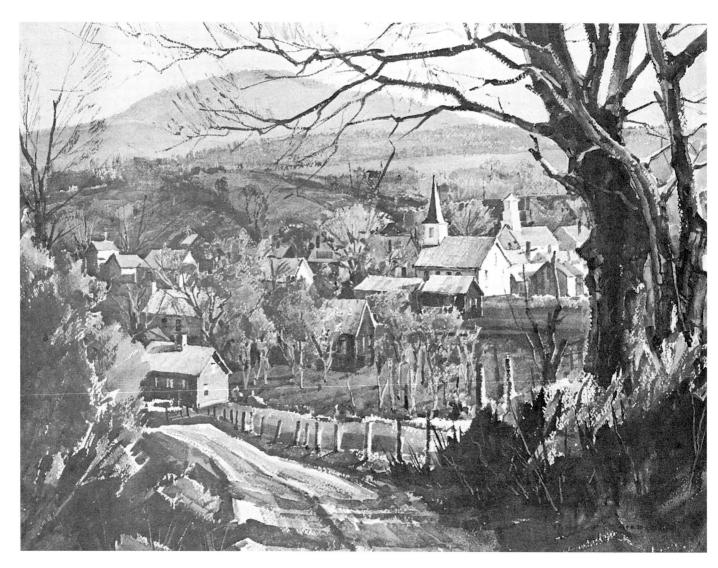

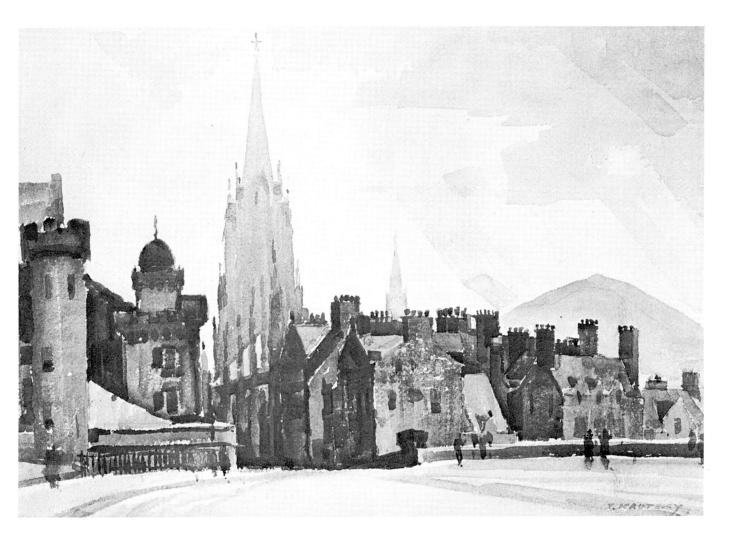

Edinburgh, Scotland

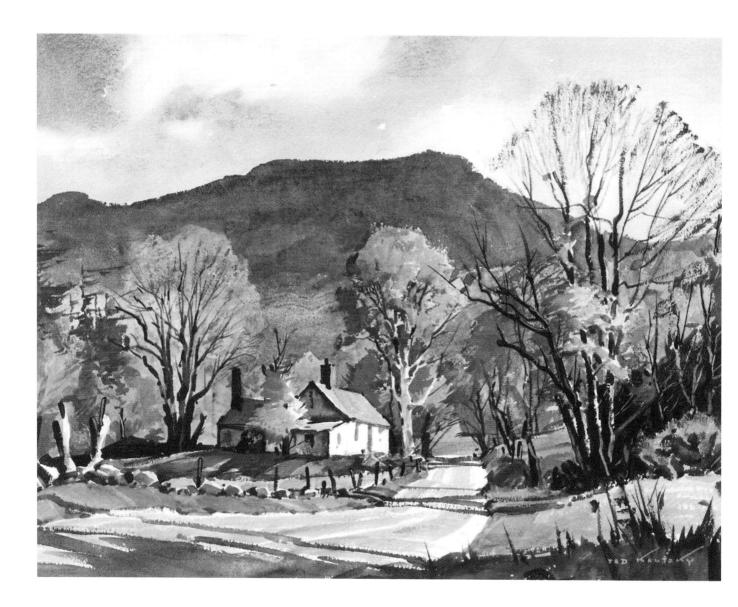

TOWARD SMUGGLER'S NOTCH

Size of original: 22" by 30". Painted on 300-pound, medium-rough D'Arches. Palette: French Ultramarine Blue, Cobalt Blue, Alizarin Crimson, Raw Sienna, Burnt Umber, Aureolin Yellow, Hooker's Green Number 2.

Order of painting: 1. Sky. 2. Mountain silhouette, using some dry-brush strokes at the top to indicate trees and leaving white paper for foliage masses. 3. Dark trees and shadows at right, and shadow in foreground to edge of road. 4. Dark trees, shadows and dark side of house in middleground. 5. Grassland on both sides of road. 6. Late autumn foliage; fence and rocks along the road. 7. The road, using sweeping strokes in the same direction as the road and narrower at the top to emphasize the perspective. 8. The shadows across the road and the sunlit side of the house.

MIDWEST FARM SCENE

Size of original: 20" by 25". Painted on 300-pound D'Arches, medium-rough surface.

Palette: Lemon Yellow, Cobalt Blue, Hooker's Green Number 2, Burnt Umber, Vermilion, Raw Sienna.

Order of painting: 1. Sky pattern and distant background trees. 2. Dark foliage and dark trunk areas of foreground tree. Shadow in right foreground. 3. Evergreen trees in background, their cast shadow and dark area at left. 4. The plowed field, leaving white patches for the tractor and fence posts. 5. The fields to the left, the pasture on the right, and the sunlit grasses in the foreground. White areas were left for the cows. 6. Final modeling of the foreground tree. 7. The cows, the house and the barn, except the roof and silo, which are modeled last along with the foreground fence posts and ground area.

Above and facing page: Two studies in value and design. The cornfield is a finished pencil sketch; notice the reflected light on the shadow sides of the shocks and the use of line and mass to focus attention.

ALONG THE ATLANTIC COAST

Size of original: 22" by 25". Painted on 300-pound D'Arches, medium-rough surface.

Palette: Burnt Umber, Cadmium Yellow, Hooker's Green Number 2, Vermilion, Cobalt Blue, Ultramarine Blue.

Order of painting: 1. The shack on the right leaving white areas for the lobster buoys and the life belt. 2. The wooden wharf and the shadow area under it. 3. The foreground rocks, starting at the left and working around to the sunlit rocks on the right. 4. The cement wharf and shacks on the left. The boats moored beside the wharf. 5. The sky pattern and background hill. 6. The background boats. 7. The water and the water reflections. 8. The gulls, carefully positioned to keep the eye within the picture.

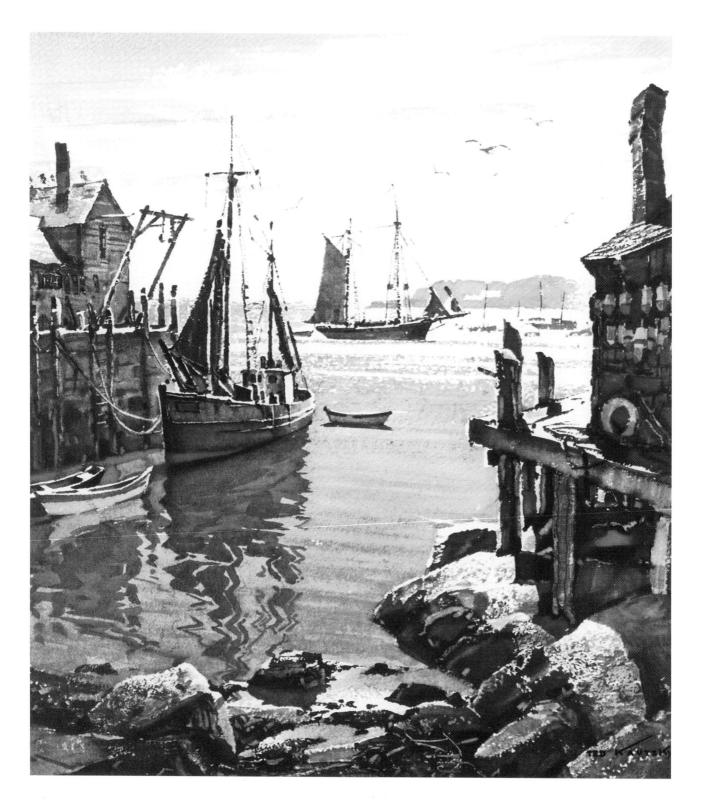

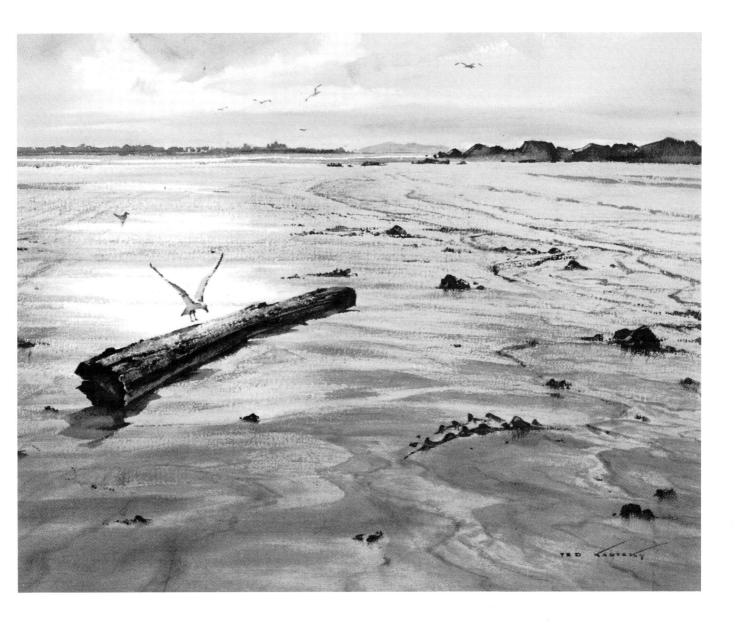

MORNING ON THE BEACH

Size of original: 22" by 30". Painted on medium-rough Whatman. Palette: Winsor Blue, Cobalt Blue, Burnt Umber, Hooker's Green Number 2, Cadmium Yellow.

Order of painting: 1. The sky. The graded horizontal strokes, done on wet paper, emphasize the direction of the early morning sun. 2. The background hills, starting with the rocky promontory at the right. 3. The water, using a wash graded from dark at the bottom to light at the top, with passages of white paper for highlighted areas. Darker values and color were superimposed later, while the wash was still slightly damp, to indicate water movement and depth. Dry-brush strokes gave shimmer and the darks of the water established distance and perspective. 4. The log and its reflection. 5. The small rocks and the seaweed, carefully placed in relation to water movement, perspective and compositional interest. 6. The gulls. Note the modeling of the foreground gull, with reflected sunlight hitting the underside of one wing.

Above: Action sketches of seagulls. Facing page: One of many value studies made before painting Low Tide on the Beach, page 132.

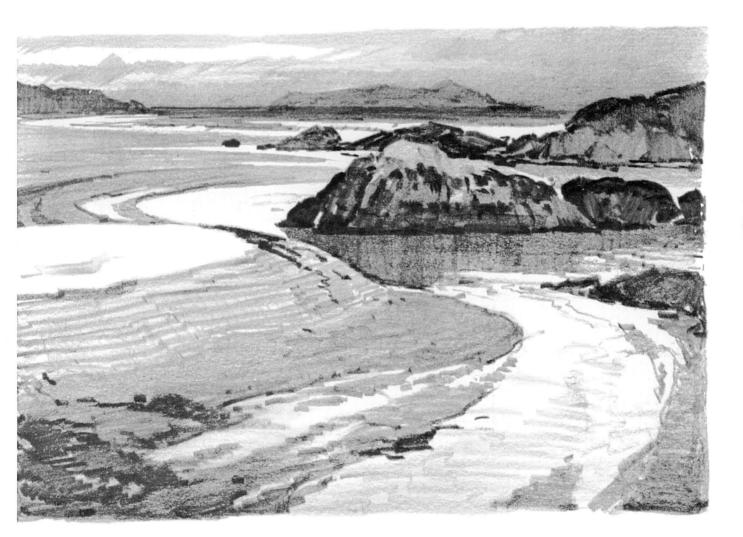

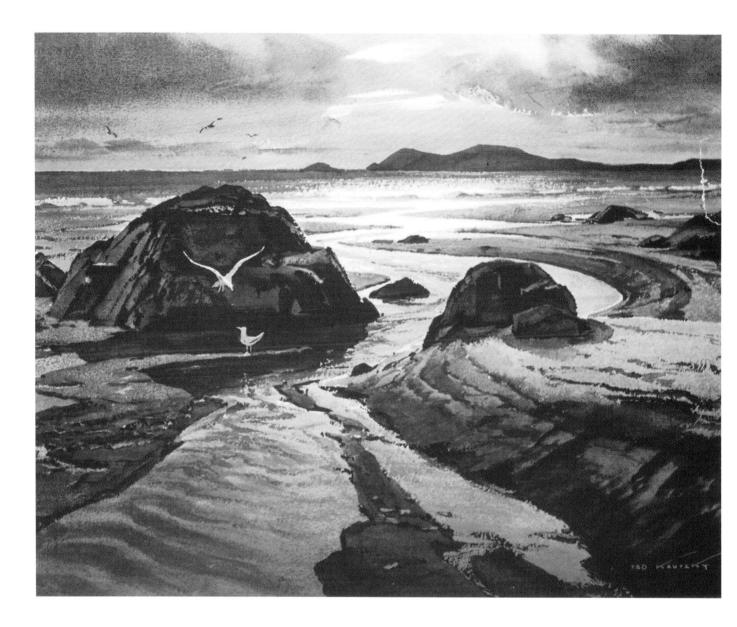

LOW TIDE ON THE BEACH

Size of original: 22" by 30". Painted on medium-rough, 300-pound D'Arches. *Palette:* Raw Sienna, Burnt Umber, Raw Umber, Ultramarine Blue, Cobalt Blue, Hooker's Green Number 2.

Order of painting: 1. The sky, painted wet. 2. The foreground rocks, done with rich dark color, and carefully worked around the outlines of the white gulls. 3. The distant hills and the dark passage of adjacent sea. 4. The sandy flatland, working from dark to light. 5. The tidal creek and modeling of the gulls.

AFTER THE STORM

Size of original: 22" by 25". Painted on 300-pound, medium-rough D'Arches. *Palette:* French Ultramarine Blue, Hooker's Green Number 2, Raw Sienna, Burnt Umber, Vermilion.

Order of painting: 1. Dark background rocks. 2. Shaded sides of foreground rocks and debris at right. 3. Sand, graded from dark to light, with dry-brush strokes to indicate moist middle ground. The dark shadows that indicate undulating, rippled sand, were superimposed. 4. Light background rocks, tree-covered hill, water. 5. The sky, and final modeling of highlight areas.

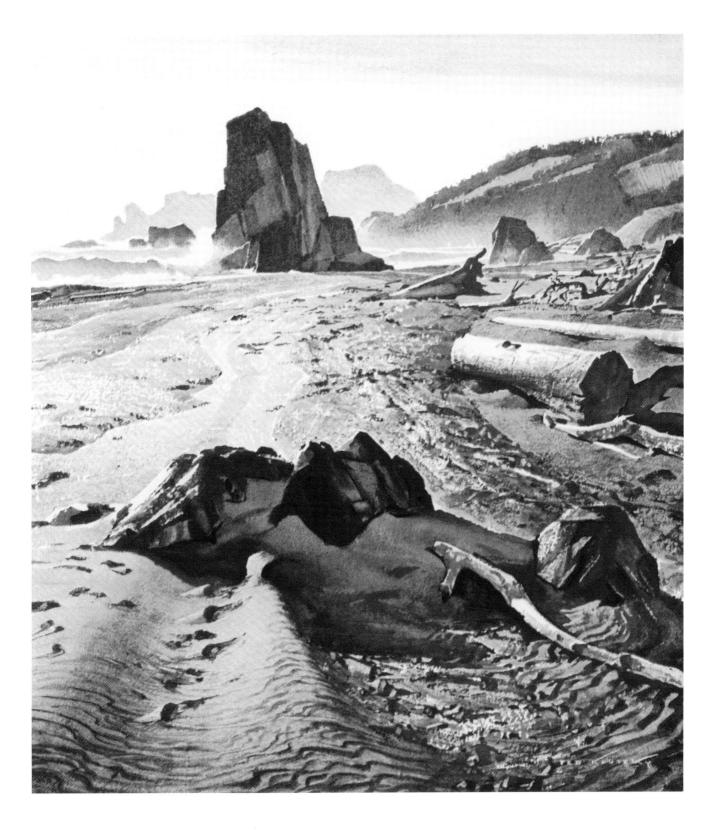

Above and facing page: Two rough, value sketches from the same subject matter. Many pictures can be painted in one area by combining changes in viewpoint, time, and mood with a little creative imagination.

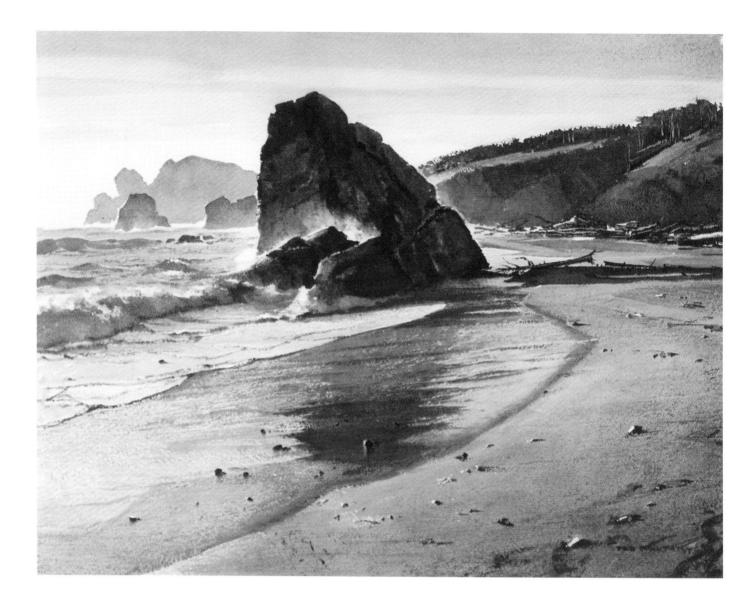

ALONG THE OREGON COAST

Size of original: 22" by 30". Painted on Whatman, medium-rough surface. Palette: Hooker's Green Number 2, Burnt Umber, Raw Sienna, Cobalt Blue, Davy's Gray.

Order of painting: 1. Sky. 2. Large dark rock, leaving white paper where spume hits rock crevices. 3. Tree covered hill at right and fog-shrouded background rocks and hill. 4. Wash over sandy beach with texture and debris superimposed. 5. Water, with careful attention to the variations in value and color. 6. The water reflections. Notice that the reflection does not come through the spumy water of the just-broken wave.

DOVER BOOKS ON ART INSTRUCTION

PRACTICAL GUIDE TO ETCHING AND OTHER INTAGLIO PRINTMAKING TECHNIOUES. Manly Banister. (25165-9) ILLUSTRATING NATURE: HOW TO PAINT AND DRAW PLANTS AND ANIMALS, DOrothea Barlowe and Sy Barlowe. (29921-X) PAINTING GARDENS, Norman Battershill. (Available in U.S. and Canada only.) (28401-8) ACRYLIC PAINTING: A COMPLETE GUIDE, Wendon Blake. (29589-3) ACRYLIC WATERCOLOR PAINTING, Wendon Blake. (29912-0) FIGURE DRAWING STEP BY STEP, Wendon Blake. (40200-2) LANDSCAPE DRAWING STEP BY STEP, Wendon Blake. (40201-0) OIL PORTRAITS STEP BY STEP, Wendon Blake. (40279-7) WATERCOLOR LANDSCAPES STEP BY STEP, Wendon Blake. (40280-0) TEXTURE AND DETAIL IN WATERCOLOR, Richard Bolton. (Available in U.S. and Canada only.) (29509-5) BRIDGMAN'S LIFE DRAWING, George B. Bridgman. (22710-3) CONSTRUCTIVE ANATOMY, George B. Bridgman. (21104-5) DRAWING THE DRAPED FIGURE, George B. Bridgman. (41802-2)) ANIMAL SKETCHING, Alexander Calder. (20129-5) CHINESE PAINTING TECHNIQUES, Alison Stilwell Cameron. (40708-X) CARLSON'S GUIDE TO LANDSCAPE PAINTING, John F. Carlson. (22927-0) PATTERN DESIGN, Archibald H. Christie. (22221-7) THE ARTISTIC ANATOMY OF TREES, Rex Vicat Cole. (21475-3) PERSPECTIVE FOR ARTISTS, Rex Vicat Cole. (22487-2) ART STUDENTS' ANATOMY, Edmond J. Farris. (20744-7) ABSTRACT DESIGN AND HOW TO CREATE IT, Amor Fenn. (27673-2) PAINTING MATERIALS: A SHORT ENCYCLOPEDIA, Rutherford J. Gettens and George L. Stout. (21597-0) FIGURE PAINTING IN OIL, Douglas R. Graves. (29322-X) LIFE DRAWING IN CHARCOAL, Douglas R. Graves. (28268-6) ABSTRACTION IN ART AND NATURE, Nathan Cabot Hale. (27482-9) CREATING WELDED SCULPTURE, Nathan Cabot Hale. (28135-3) FIGURE DRAWING, Richard G. Hatton. (21377-3) HAWTHORNE ON PAINTING, Charles W. Hawthorne. (20653-X) GEOMETRIC PATTERNS AND HOW TO CREATE THEM, Clarence P. Hornung. (41733-6) THE ART OF ANIMAL DRAWING: CONSTRUCTION, ACTION ANALYSIS, CARICATURE, Ken Hultgren. (27426-8) MODELLING AND SCULPTING THE HUMAN FIGURE, Edouard Lanteri. (25006-7) MODELLING AND SCULPTING ANIMALS, Edouard Lanteri. (25007-5) THE PAINTER'S METHODS AND MATERIALS, A. P. Laurie. (21868-6) ETCHING, ENGRAVING AND OTHER INTAGLIO PRINTMAKING TECHNIQUES, Ruth Leaf. (24721-X)

(continued on back flap)

(continued from front flap)

THE ART OF CHINESE CALLIGRAPHY, Jean Long. (41739-5)

THE ART OF ETCHING, E. S. Lumsden. (20049-3)

ANATOMY FOR ARTISTS, Reginald Marsh. (22613-1)

FIGURE SCULPTURE IN WAX AND PLASTER, Richard McDermott Miller. (Available in U.S. only.) (25354-6)

PERSPECTIVE MADE EASY, Ernest Norling. (40473-0)

PAINTING AND DRAWING CHILDREN, John Norton. (41803-0)

DRAWING OUTDOORS, Henry C. Pitz. (28679-7)

COMPOSITION IN ART, Henry Rankin Poore. (23358-8)

PRINCIPLES OF PATTERN DESIGN, Richard M. Proctor. (26349-5)

THE MATERIALS AND METHODS OF SCULPTURE, Jack C. Rich. (25742-8)

SCULPTURE IN WOOD, Jack C. Rich. (27109-9)

THE ELEMENTS OF DRAWING, John Ruskin. (22730-8)

ANATOMY: A COMPLETE GUIDE FOR ARTISTS, Joseph Sheppard. (27279-6)

DRAWING THE LIVING FIGURE, Joseph Sheppard. (26723-7)

SCULPTURE: PRINCIPLES AND PRACTICE, LOUIS Slobodkin. (22960-2)

OIL PAINTING TECHNIQUES AND MATERIALS, Harold Speed. (25506-9)

THE PRACTICE AND SCIENCE OF DRAWING, Harold Speed. (22870-3)

THE ANATOMY OF THE HORSE, George Stubbs. (23402-9)

MATERIALS AND TECHNIQUES OF MEDIEVAL PAINTING, Daniel V. Thompson. (20327-1)

The Practice of Tempera Painting, Daniel V. Thompson. (20343-3)

VASARI ON TECHNIQUE, Giorgio Vasari. (20717-X)

CREATIVE PERSPECTIVE FOR ARTISTS AND ILLUSTRATORS, Ernest W. Watson. (27337-7)

MOSAIC AND TESSELLATED PATTERNS, John Scott Willson. (24379-6)

THE ART OF THREE-DIMENSIONAL DESIGN, LOUIS WOLCHONOK. (22201-2)

PENCIL DRAWING, Michael Woods. (25886-6)

ZORACH EXPLAINS SCULPTURE: WHAT IT MEANS AND HOW IT IS MADE, William Zorach. (29048-4)

Paperbound unless otherwise indicated. Available at your book dealer, online at **www.doverpublications.com**, or by writing to Dept. 23, Dover Publications, Inc., 31 East 2nd Street, Mineola, NY 11501. For current price information or for free catalogs (please indicate field of interest), write to Dover Publications or log on to **www.doverpublications.com** and see every Dover book in print. Each year Dover publishes over 500 books on fine art, music, crafts and needlework, antiques, languages, literature, children's books, chess, cookery, nature, anthropology, science, mathematics, and other areas.

Manufactured in the U.S.A.

DOVER COLORING BOOKS OF ART AND DESIGN

MANDALA DESIGNS, Martha Bartfeld. (41034-X) COLOR YOUR OWN MARY CASSATT MASTERPIECES, Mary Cassatt. (41040-4) COLOR YOUR OWN GAUGUIN PAINTINGS, Paul Gauguin. (41325-X) COLOR YOUR OWN ABSTRACT ART MASTERPIECES, Muncie Hendler. (40800-0) COLOR YOUR OWN MATISSE PAINTINGS, Muncie Hendler. (40030-1) GEOMETRICAL DESIGN, Spyros Horemis. (20180-5) VISUAL ILLUSIONS, Spyros Horemis. (21595-4) KALEIDOSCOPIC DESIGN, Lester Kubistal. (40566-4) OP ART, Jean Larcher. (23172-0) THE 3-D ALPHABET, Jean Larcher. (23632-3) CELTIC ANIMALS, Mallory Pearce. (29729-2) DAZZLING DESIGNS, Koichi Sato. (40031-X) OPTICAL ILLUSIONS, Koichi Sato. (28330-5) ANCIENT EGYPTIAN DESIGN, Ed Sibbett Jr. (23746-X) CELTIC DESIGN, Ed Sibbett Jr. (23796-6) JAPANESE PRINTS, Ed Sibbett Jr. (24279-X) 3-D DESIGNS, Wil Stegenga. (40363-7) \$2.95 COLOR YOUR OWN VAN GOGH PAINTINGS, Vincent Van Gogh. (40570-2) PRISMATIC DESIGN, Peter Von Thenen. (23716-8)

Paperbound unless otherwise indicated. Available at your book dealer, online at **www.doverpublications.com**, or by writing to Dept. 23, Dover Publications, Inc., 31 East 2nd Street, Mineola, NY 11501. For current price information or for free catalogs (please indicate field of interest), write to Dover Publications or log on to **www.doverpublications.com** and see every Dover book in print. Each year Dover publishes over 500 books on fine art, music, crafts and needlework, antiques, languages, literature, children's books, chess, cookery, nature, anthropology, science, mathematics, and other areas.

Manufactured in the U.S.A.